PAINT RADIANT REALISM IN WATERCOLOR, INK & COLORED PENCIL

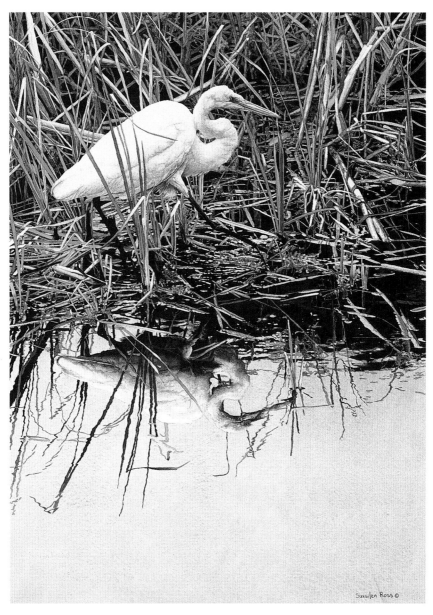

STEPPING OUT—GREAT EGRET
26" × 20" (66cm × 51cm)

PAINT
RADIANT
REALISM
IN WATERCOLOR, INK
& COLORED PENCIL

Sueellen Ross

NORTH LIGHT BOOKS
CINCINNATI, OHIO

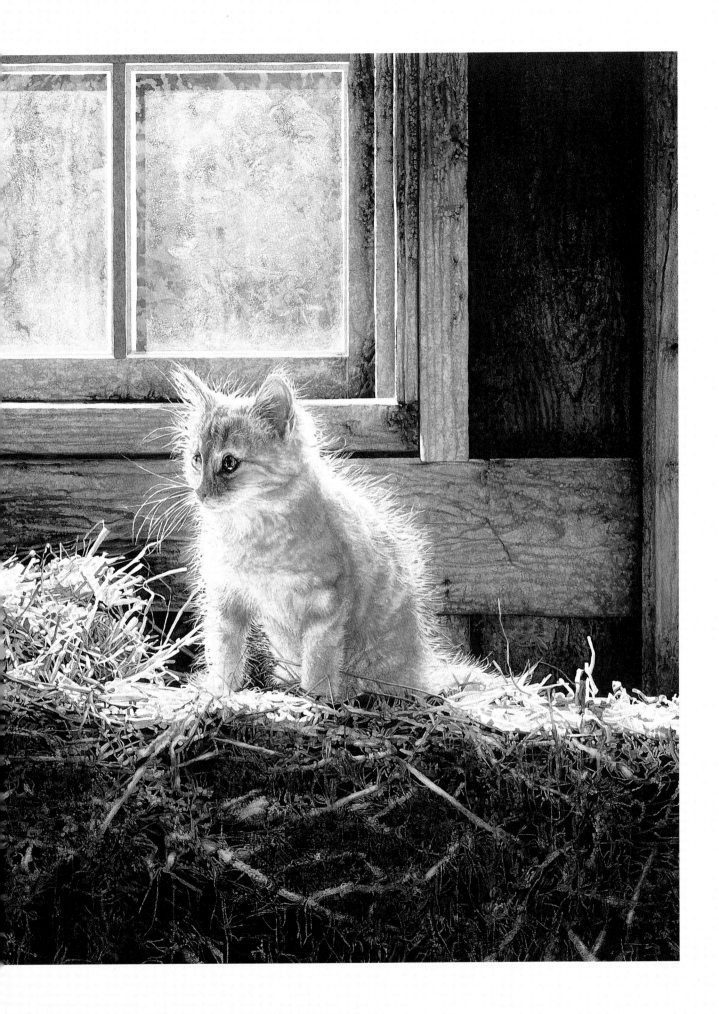

ABOUT THE AUTHOR

Sueellen Ross began drawing animals as soon as she could hold a pencil. She's still at it, after almost twenty years as a full-time professional artist.

Especially known for her masterful and delightful cat and wildlife portraits, Sueellen combines her passion for making art with her love of animals to create works of strong design and subtle wit.

Her paintings, etchings and other prints have been exhibited worldwide. She is a frequent contributor to the prestigious *Birds in Art* show at the Leigh Yawkey Woodson Art Museum in Wausau, Wisconsin, and the *Arts for the Parks* show sponsored by the National Park Foundation in Jackson Hole, Wyoming.

Her work can be seen in *The Best of Wildlife Art*, edited by Rachel Rubin Wolf, and Bart Rulon's *Painting Birds Step by Step*, both published by North Light Books (Cincinnati, Ohio). Her work is also displayed in Jeffrey Whiting's *Owls of North America*, published by The Heliconia Press, Inc. (Clayton, Ontario).

Sueellen is married and lives in Seattle, Washington.

Paint Radiant Realism in Watercolor, Ink & Colored Pencil. Copyright 1999 by Sueellen Ross. Manufactured in China. All rights reserved. No part of this book may be reproduced in any form or by any electronic or mechanical means including information storage and retrieval systems without permission in writing from the publisher, except by a reviewer, who may quote brief passages in a review. Published by North Light Books, an imprint of F&W Publications, Inc., 4700 East Galbraith Road, Cincinnati, Ohio 45236. (800) 289-0963. First Paperback Edition 2003.

Other fine North Light Books are available from your local bookstore, art supply store or direct from the publisher.

07 06 05 04 03 5 4 3 2 1

Library of Congress has catalogued hardcover edition as follows:

Ross, Sueellen.
 Paint radiant realism in watercolor, ink & colored pencil / by Sueellen Ross.—1st ed.
 p. cm.
 Includes index.
 ISBN 0-89134-900-6 (hardcover) ISBN 1-58180-485-7 (pbk: alk. paper)
 1. Mixed media painting—Technique. 2. Realism in art. I. Title.
ND1505.R67 1999
751.4′2—dc21 99-21136
 CIP

Edited by Jennifer Lepore
Production Edited by Nicole Klungle and Jennifer Lepore
Designed by Brian Roeth
Cover art: *First Spring*, 10″ × 10¾″ (25cm × 27cm)
Page 2-3 art: *Barn Kitten*, 16½″ × 20½″ (42cm × 52cm)

DEDICATION

For Richard

ACKNOWLEDGMENTS

My partners in this book project are as follows:

Richard Lyon: my husband, scrivener, computer whiz, cheerleader, paver of smooth roads and conduit to the twenty-first century.

David Azose: my official book photographer and longtime friend whose talent and good-natured flexibility made scheduling remarkably easy.

Jennifer Lepore: my editor—a gentle but unrelenting perfectionist who got me to do (and redo) things for the book that I would have refused to do for anyone else.

Pat and Dan Howard: my career-partners, agents, publishers and treasured friends who, with the staff at the Howard/Mandville Galleries, tracked and shipped paintings, scheduled everything around the book and made everything easier.

Zachary Price, Joan Pinney, Martin Wilke, Susan Hanson: artists with cameras as well as brushes and pens, who shared some of their cat, bird, and wild mammal photos.

Animal-loving friends from all over the country who have shared their favorite pets with me by sending me photos.

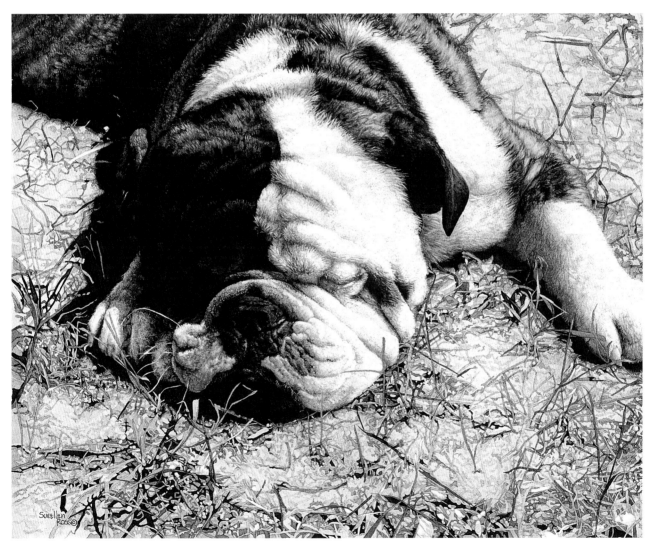

EARTHBOUND
10½″ × 12½″ (27cm × 32cm)

TABLE OF CONTENTS

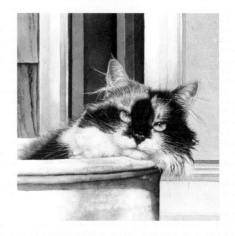

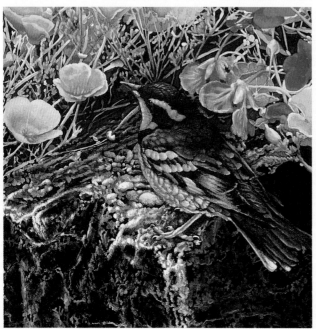

FOREWORD

The first time I met Sueellen Ross was at *Birds in Art* at the Leigh Yawkey Woodson Art Museum in Wausau, Wisconsin in 1987. We both had had paintings juried into its prestigious annual bird art exhibition for the first time. We instantly became friends. She thought I resembled her nephew. With our blond hair and similar coloring, we began to joke to people that she was my aunt and I was her nephew.

Aside from my admiration for her as a person, I am a great fan of her art. Though she is known for her paintings of domestic cats, she is also an expert at painting and drawing other types of wildlife. Her strong use of color and good sense of design, combined with a strong drawing ability and a great empathy for her subjects, make her work unique and instantly recognizable. In addition, she often depicts her subjects in suburban settings, giving viewers art they can relate to—subjects and scenes they may have observed and experienced in their own backyards. The title of her book is appropriate. In each of the various mediums she uses to create her art, a Sueellen Ross artwork is always radiant and sparkles, just as she does.

Terry Isaac

Terry and Sueellen hunting for reference material.

Terry's cat, George, strikes a characteristically haughty pose for Sueellen's hand-colored etching of the same name.

GEORGE
Sueellen Ross
Hand-colored etching
7" × 10½" (18cm × 27cm)

INTRODUCTION

When faced with an art project, have you ever said, "What made me think I could pull this off?" Or, "Why ruin a perfectly good pencil (or pen-and-ink) drawing?" If so, this book is for you.

Do you panic at the sight of a blank piece of paper? Want structure and a clear progression of steps? Do you love to draw but are afraid to paint? Do you panic when a big glob of oil paint obliterates your carefully planned drawing? Are you a pencil artist, pen-and-ink artist or printmaker who wants to use more color? Are you a colored pencil artist who wants to speed up? If you're a watercolorist, do you feel your work needs more punch and contrast? Do you want a new look? If so, this book is for you, too.

I developed my mixed media technique to:

- take advantage of my strengths as an artist.
- compensate for my weaknesses, several of which are listed in the above paragraph.
- get every benefit from each medium I use, while avoiding every disadvantage.
- find a way of working that's all mine.

I was no genius with oil paints and stiff, square brushes. I was tentative and uncomfortable with big, splashy watercolors. But I could draw. So I designed a new way of painting that would circumvent all those things I wasn't good at and would keep me safe.

With controlled applications of layer after layer of different media, I can build a painting that is full of color and richness and depth and intensity. I can do this without losing the layers underneath, or the drawing. And, if one layer doesn't live up to expectations, I can almost always fix it with the next!

This book is not a substitute for a good beginner's class in drawing or watercolor technique. At its best, it is a challenge to the artist in you to find your very own technique—one that shows off your special talents and makes up for any shortcomings. One that takes advantage of the special qualitites of each medium and comes up with a total that is greater than all its parts. One that makes your work look different from anyone else's, and, just maybe, better than anything you've done before.

Not everything you find in this book will fit your style, tastes or talents. So take what works for you, add your own discoveries and come up with your own unique way of working.

Have fun!

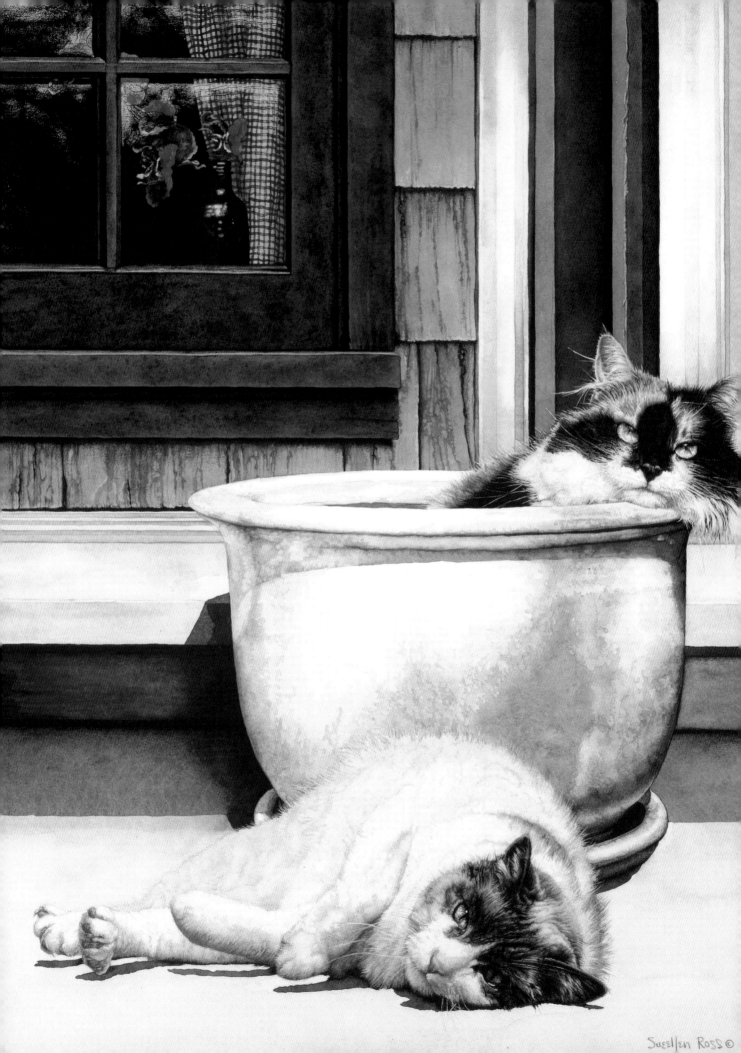

Suelllen Ross ©

GETTING STARTED

Without realizing it, you are probably already a mixed-media artist. Have you drawn anything in pencil? Have you tried crayons, chalk, poster paint or pen and ink? If you've done any art at all, you will find that you already own at least some of the materials needed to get started.

You are going to use four common media—graphite pencil, black India ink, watercolor and colored pencil—in that order and in easy-to-control stages. I encourage you to substitute my suggested materials with what you have on hand. I can't guarantee the results, of course, but you might find something that works equally well for you. Just remember that your India ink must be waterproof and that your colored pencils must be wax or oil based.

MY BLUE HEAVEN
16⅜" × 21½" (42cm × 55cm)

Painting Cat Paradise

This is my idea of the perfect environment for a couple of lazy cats: warm midday sun, a perch on a porch, the right sized pot.

The pot is done in loose watercolor; the cats are the usual mix of ink, watercolor and colored pencil. The reflections in the window are colored pencil on India ink.

MATERIALS

WATERCOLOR PAPER

Over the years I haunted art supply stores for the perfect paper. I wanted it to be a beautiful, rich white, with a satin-smooth surface. I wanted it to be hefty and tough and forgiving. I wanted it to enhance the brilliance of my watercolors and to take the ink without bleeding. And, I wanted it to be cheap.

I found everything I wanted except for the cheap part: Arches 140-lb. (300gsm) hot-pressed paper (for a creamy off-white) and Lanaquarelle 140-lb. (300gsm) hot-pressed paper (for a cooler, brighter white). I recommend that everyone—from beginner to professional—purchase the best paper available. It's worth it. The great results are a real morale booster.

Gator Board vs. Foamboard
Gator board (in the back) is much sturdier but more expensive than foamboard. So I cut a piece of foamboard to fit each painting I do.

I use these other supplies for the drawing and inking steps of a painting: white art tape to affix the paper to a backing; an HB graphite pencil; two types of ink pens (Koh-i-noor Rapidograph refillable and Pigma Micron nonrefillable); India ink; and an ink brush.

BACKING

You need a smooth, stiff, lightweight board to tape your paper on. A backing board protects your paper from damage and allows you to stretch your paper tight so it can't curl or buckle. You won't need it to be much larger than your paper; a board that's too big tends to knock everything off your table when you try to move it.

Gator board and foamcore board are my two favorite supports. With its smooth, plastic surface and a hardened foam interior, Gator board is rigid, tough and lightweight. Its initial cost is greater than foamcore board, but it lasts forever. Gator board is hard to cut, so buy the exact sizes you want.

I generally use foamcore board or foamboard. Foamboard consists of two sheets of heavy paper with foam in the middle, so it's not a permanent material like Gator board. Cut a piece of it just a bit larger than the painting you're about to work on. Attach each corner of your paper to the foamboard with a piece of white art tape. (This way, you can tighten the paper as it buckles and expands with the various media.) Keep the paper right on the foamboard until the painting is finished, has been photographed, and is safely in the hands of the framer. By this time, the foamboard is pretty beat up, so don't use it for another painting.

INK

Black, waterproof ink is basic to my technique. I use India (black) FW Acrylic Artists Ink. I love its deep-black matte finish, its plasticity and its covering capacity.

INK PENS

You'll be applying ink with a pen in the small, detailed areas of your work. If you haven't used pen and ink before, start out with a drawing pen that comes with its own supply of black, waterproof ink. Pentel Ceramicron and Micron Pigma pens work like markers, and come in several line widths. A medium-fine point is all you need to start.

These drawing pens have a limited supply of ink, so I use technical pens, which are refillable. My favorite is a Koh-i-noor Rapidograph pen with a size 00 nib, which can be tricky to use at first.

The nib of a technical pen is actually a tube with a pin through it. When you press the pen onto your paper, the pin is pushed up the tube, releasing the ink. It takes a bit of practice to keep the flow of ink smooth and steady.

Refilling a technical pen can be messy at first. Also, the pen tips need to be cleaned from time to time, or they will clog. But technical pens are, quite simply, the finest, most flexible, most precise ink pens around.

By the time you run out of ink in your drawing pen, you'll know if you're ready to graduate to a technical pen. However, there is no need to change unless you feel compelled to do so.

INK BRUSHES

You'll need a brush to apply ink to larger areas of your work. Designate a mid-sized, reasonably priced brush with a good point as your ink brush. A Cotman or Princeton Round no. 6 brush works well. Once you have dipped a brush in India ink, do not use it for anything else. Soap and warm water will keep it pliable and useable for a long time, but the ink will contaminate other colors. Put a dab of nail polish or tape on your ink brush handle to remind yourself to use it only for ink.

BASIC WATERCOLORS

The rewards that come from using superior watercolors on superior paper are unmatched. The higher the quality of paint, the higher the percentage of pigment-to-binder it contains. As a result, a little paint goes a long way and has more brilliance.

Start with little tubes; you'll be amazed how far they go.

Those of you who are already watercolorists can use the paints you already have, adding any of the colors shown below not already on your palette. If you're a beginner, buy a small set of Winsor & Newton watercolors, supplementing it with any of the colors shown below not already in the set.

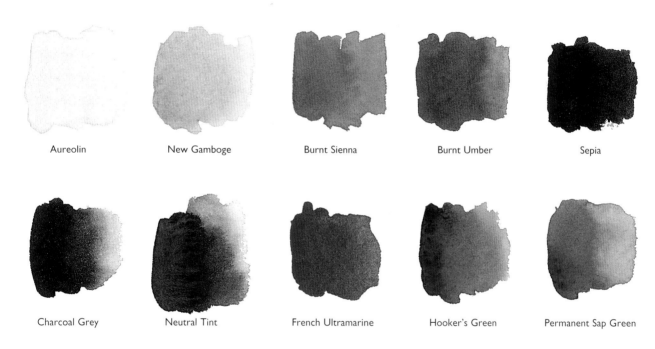

| Aureolin | New Gamboge | Burnt Sienna | Burnt Umber | Sepia |
| Charcoal Grey | Neutral Tint | French Ultramarine | Hooker's Green | Permanent Sap Green |

Basic Watercolor Palette (Winsor & Newton)
By themselves or mixed with other colors, these colors constitute my basic palette. If you like the effects I get with them, buy a small tube of any color you don't already have.

If you are new to watercolor, buy yourself an introductory set of Winsor & Newton watercolors and add any of these colors that aren't included.

CHECK COLOR NAMES

Carefully check the names on your tubes before buying them. French Ultramarine is different from Ultramarine. New Gamboge is different from Gamboge. I blush to tell you how long it took me to figure this out. Get it right the first time. Avoid the bewilderment and despair I felt at muddy mixtures and inconsistent results.

most black

ges all the

parent gray

...ots of water. It is

...olor to use over India

...dulls the shiny surface of the ink but leaves no gritty film or milky color. Charcoal Grey makes beautiful, deep shadows on white areas. It is a great pigment for fur, feathers and hair. It glazes and darkens without polluting other colors. I use it as the next-lighter pigment (after ink) in many of my paintings.

Sepia—a cool, gray-brown, with so much black in it that it goes on very dark. Use it for natural textures—fur, feathers, wood, warm shadows.

Burnt Umber—this "warming agent" is a heavenly, transparent golden brown when used straight from the tube. It dilutes to a pale buff color for warming up wood, fur, feathers and almost every natural thing.

Permanent Sap Green—a bright, vibrant color that reminds me of summer in upstate New York. Yes, it really is that green. But nobody would believe it, so add other colors to calm it down. Adding some Sepia or Burnt Sienna provides a range of natural-looking olive greens. Add yellows, and the colors of newly emergent foliage pop out.

Opera (Holbein)

Bright Red
(Winsor & Newton)

Permanent Alizarin
Crimson
(Winsor & Newton)

Payne's Grey
(Winsor & Newton)

FAVORITE EXTRA WATERCOLORS

Opera (Holbein), *Bright Red* (Winsor & Newton) *and Permanent Alizarin Crimson* (Winsor & Newton)—use these colors side by side for any number of pink and red flowers. Opera is a hot pink that bounces against any warm red. Try Permanent Alizarin Crimson for red shadows. These colors are not essential, but they sure are fun.

Neutral Tint and Payne's Grey (Winsor & Newton)—these are useful shadow colors. Both colors are almost black straight from the tube. Neutral Tint has a purple cast and Payne's Grey is more blue-green.

Favorite Extra Watercolors

Here are some colors that give me special pleasure. Bounce a bright blue-pink off a hot orange and shade it with cool Permanent Alizarin Crimson for a myriad of flowers. Cast a dark, rich shadow with Payne's Grey. Or gild and glaze with Daniel Smith's translucent Quinacridone colors.

Quinacridone Gold
(Daniel Smith)

Quinacridone
Burnt Orange
(Daniel Smith)

Quinacridone
Burnt Scarlet
(Daniel Smith)

Quinacridone Gold (Daniel Smith)—the quinacridone colors by Daniel Smith are new additions to my palette; I am quickly and happily becoming dependent on their brilliance and translucency. A delicious selection of golds, earth tones and reds has prompted me to use more glazing than ever in my work. Quinacridone Gold is now a staple in my palette. A deep, red-bronze when used heavily, it dilutes to a glittering, pale gold.

Quinacridone Burnt Orange and Burnt Scarlet (Daniel Smith)—I've used both of these colors on the red cat in *Sunspot*, page 43.

FAVORITE WATERCOLOR COMBINATIONS

French Ultramarine and Burnt Sienna—these pigments, which are coarse and sedimentary, try to get as far away from each other as they can. Close up, red and blue pigments swirl and clump and never mix. From a little distance, the mixture of the two looks gray—a warm, earthy gray if you add extra Burnt Sienna, and a cool, shadowy purple-gray if you add more blue. I use this combination for deep background washes and for shadowy glazes to push things further in the background.

Hooker's Green and Sepia—combine to make a rich, foresty green which goes almost to black and dilutes to the palest, silvery leaf green. Add more Hooker's and you have a spruce tree. Add more Sepia and the tree turns deciduous. This mix is my darkest vegetation green.

New Gamboge and Burnt Sienna—combine to make great red fur, red feathers, red hair and red wood. Add more New Gamboge for a brilliant orangey gold; add more sienna for a deeper, coppery red.

Raw Umber and Rose Doré—I combine these colors to make the color for animal noses and ears and my favorite flesh tone. You can substitute Rose Madder or other pinks for the Rose Doré, but you'll lose some of the peach in your flesh.

WATERCOLOR BRUSHES

I like watercolor brushes that keep their points and hold a lot of paint. Otherwise, I'm not too fussy. I've spent too many years ruining brushes by hand-coloring etchings to plunk down lots of money on a single brush. You'll do fine with a nice

Watercolor Collection
I keep my watercolor tubes in a giant but portable plastic box made by Art-bin. To remember what all these colors look like, I paint a sample of each new color as I get it. My brush collection is shown on the right, along with several types of water containers.

watercolor brush set by Cotman, Princeton or Grumbacher. My two favorite brushes are a Princeton no. 10 round for bigger areas and a no. 4 or no. 6 for details. They're all you need to get started.

Favorite Watercolor Combinations

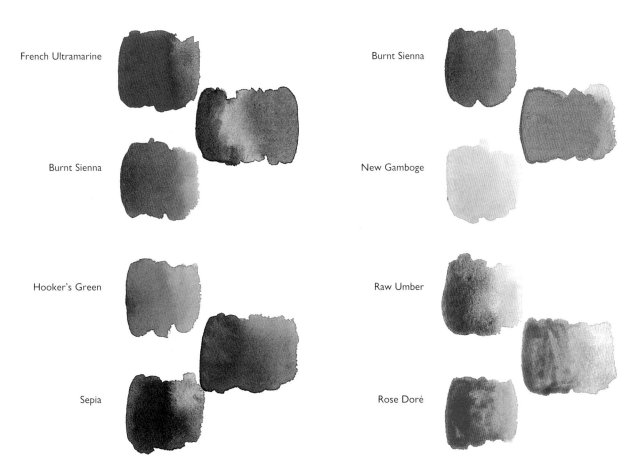

French Ultramarine

Burnt Sienna

Burnt Sienna

New Gamboge

Hooker's Green

Raw Umber

Sepia

Rose Doré

LIQUID ACRYLICS

A few years ago I developed a technique for doing fur, feathers, and other textures that has become one of the most identifiable and unusual features of my work. This method is detailed on page 36. One of the main ingredients of this process is Winsor & Newton's Warm Grey Liquid Acrylic Colour.

PLEASE NOTE

Winsor & Newton Warm Grey Liquid Acrylic is no longer manufactured. Replace this color with Liquitex Medium Viscosity Acrylic Neutral Gray-Value 5/Mixing Gray throughout the demonstrations in this book.

Combining Warm Grey Liquid Acrylic Colour and Burnt Umber watercolor would seem unlikely. Yet in combination, they form the mainstay of my fur and feather technique. I use the Warm Grey acrylic because with it I can shadow my whites without fear of turning them dark or dirty. You can apply repeated washes of this color, and it will remain a soft, warm, midtone gray. When you glaze a final coat of Burnt Umber watercolor on top, the gray glows with warmth.

One thing to keep in mind when using this gray is that it needs to be stirred constantly to keep the heavy stuff from sinking to the bottom. This is necessary for the color to work properly.

COLORED PENCILS

I love pencils. Nothing is easier to control than pencils—not pens, brushes, charcoal or chalk. Add to that control the vivid, heavy color of oils and the soft, fuzzy texture of chalk, and you have colored pencils—the last stage of my technique.

Colored pencils are hot. As more

and more artists have discovered them, more companies have developed lines of high quality wax-based, oil-based, and watercolor pencils—Sanford, Derwent, Lyra, Bruynzeel, Caran d'Ache, Faber Castell and more; each brand has different qualities and palettes.

I still rely heavily on my old favorites, Sanford Prismacolor wax-based pencils. The following list names the colors I use most and recommend. Buy the colors individually instead of getting a box. Get extra white pencils; you'll use them.

SANFORD PRISMACOLOR
Black 935
Burnt Ochre 943
Cream 914
Crimson Red 924
French Grey 10% 1068
Light Umber 941
Olive Green 911
Orange 918
Peacock Green 907
Sepia 948
Slate Grey 936
Spring Green 913
Ultramarine 902
White 938
Yellow Ochre 942

DERWENT
Yellow Ochre 5720

I could have done any of the paintings in this book with just the

Colored-Pencil Collection
Pencils, pencils, everywhere! Here I've gathered most of my collection. All are either wax- or oil-based pencils. I mainly use Sanford Prismacolor brand.

colors listed above. In truth, however, I probably added some of these favorites.

SANFORD PRISMACOLOR
Goldenrod 1034
Indigo Blue 901
Limepeel 1005
Tuscan Red 937

DERWENT
Golden Brown 59
Olive Green 51
Sky Blue 34

LYRA
Dark Sepia 75

Start with the recommended list; you can always add to your collection if you like working with colored pencils. Remember, use only *wax-* or *oil-based*, not watercolor pencils. These colored pencils won't be affected by the water-based media that might be applied on top of them.

MORE COLORED PENCILS

Every time I visit the art store, I find new colors to try. Life is just too short. Here are some colors you might want to add to your "essentials." They are listed by brand name.

SANFORD PRISMACOLOR
The fluorescents—an unsubtle, rowdy Neon Red 1037, Neon Yellow 1035, Neon Orange 1036, Neon Pink 1038, Neon Green 1039 and Electric Blue 1040 for making things pop.
Greyed Lavender 1026—a subtle gray with a myriad of uses.
Lilac 956 and Magenta 930—purplish reds for flowers and to create iridescence.
Pale Vermillion 921—a light orange red. Great for flowers and as a blusher for fleshtones.

DERWENT
Golden Brown 59—just what it says. Great for blending and warming fur, feathers and wood.
Olive Green 51—perfect for

burnishing vegetation. Paler, harder than Sanford Olive Green. *Sky Blue 34*—a pale blue for highlights and reflections on leaves and water.

LYRA

Dark Sepia 75—almost black and very dense, it is a bridge from ink to other colors.

FABER CASTELL

Nougat 178—a pale, silvery brown. Very useful for fur and feathers.

CARAN D'ACHE

Brownish Beige 404—a very light blending gray-brown for pale fur and feathers.

ODDS AND ENDS

You've already bought enough supplies; here's your chance to use what you have around the house. I do. For instance, my favorite palettes are old Le Menu microwave trays. (Maybe I shouldn't admit it.) They don't make them anymore; I can't even find them at thrift stores and all of mine are cracking with age.

Here are some additional supplies you may find that you need:

HB (hard black) or no. 2 pencil
white plastic eraser
water jar
fixative
paper towels
white art tape
palette

OPTIVISOR MAGNIFYING LENSES

I used to be able to work on the tiniest details without glasses. Then I started using stronger and stronger reading glasses. Eventually, not even those kept me from squinting. A friend told me about OptiVisor magnifying lenses, and now I don't squint anymore. I found mine at a jewelry maker's supply store. They come in several strengths and are

Palette Collection
White plates, microwave trays . . . anything that's non-porous, white, flat and has a lip can be used as a watercolor palette. Here's a collection of my palettes, some conventional, some not. (My favorites are the Le Menu microwave trays on the left.)

attached to an adjustable headband. They flip up when you aren't using them so you don't fall on your face when you stand up. They are inexpensive and effective. Now everywhere I look, I see them. Even my dermatologist wears them.

TRACING PAPER AND GRAPHITE TRANSFER PAPER

Tracing paper is a valuable aid when you're trying to figure out what goes where in your composition. Instead of doing all your drawing directly on your good paper, try putting your preliminary ideas on heavyweight tracing paper.

Let's say you want to draw a cat sitting on a chair. You want the chair on a rug and in front of a fireplace, but you are not working from a single reference source that shows you where things should go. If you draw the cat, the chair, the rug and the fireplace separately on bits of tracing paper, you can move elements around, change their relative sizes, and play with new ideas. Once you're sure what you want, transfer your finished composition onto a new, clean piece of watercolor paper, using a lightbox. (A lightbox is a box with lights in it, covered with translucent glass. It's great for tracing and for viewing slides.)

Close Work With an OptiVisor
I wear an OptiVisor for close work. OptiVisors come in various strengths, are lightweight, and the lenses flip up when you need to move around. They work exceptionally well for me.

If you don't have a lightbox, buy some graphite transfer paper. It's easy to use, and the same piece can be used again and again. (Saral Transfer Paper comes in a roll and in five colors. Make sure you get the *graphite* paper.) Look for it in the printmaking section of your art store.

Try using the tracing paper technique if your work is very complex or if you tend to damage your paper by erasing a lot. If you're a beginner, draw directly on your paper. There'll be plenty of time later to try specialized approaches.

Preliminary Sketches
After I finalize my ideas through tracing paper sketches, I use graphite transfer paper to finalize my sketch on watercolor paper.

DEVELOPING YOUR IDEAS

CHOOSE YOUR SUBJECT

Paint what you know and love. I concentrate on animals and birds.

As a child, my idea of a perfect life was to be old enough to have all the animals I wanted. (I still can't imagine life without at least some cats.) A city kid, my chances of hanging around really big animals were limited, so, in addition to the omnipresent cats, I settled for a succession of rodents, fish, reptiles and amphibians.

I drew only cats and horses for years, but as I grew older, I expanded my repertoire to include the other animals in my world—dogs, herons, quail, shorebirds and every bird and animal that entered our yard.

Anything in the human experience—physical or mental—can be made into an exciting painting, as long as the painter really cares about the subject. What do you want to say? What do you like to do? What are your favorite creatures?

BRAINSTORM

Last night I couldn't sleep. Instead of counting sheep, I designed a painting—the classic cat-watching-bird, but with a twist. "I'll do a close-up of the bird at a feeder or maybe on a leafy limb for color? Maybe it'll be a chickadee or some bird common to our yard—several house sparrows, possibly, or a pine siskin or a pair of house finches?"

"I'll put the cat safely behind glass. Maybe I'll title it *Safety Glass*? I'll dim the colors so the focus is clearly on the bird, though the cat should be vigilant, even excited. Above all, I want the feeling to be safe and controlled."

And I went on to think about the window frame, curtain—all the details that would separate the outdoor world from the indoor.

COLLECT RESOURCES

In the morning I went to my cat and window files. I collected all the photos I had on common visitors to our bird feeders. A friend took a roll of chickadee shots for me, including the pose I finally used. I found a pine cone in the yard and used one of our bird feeders.

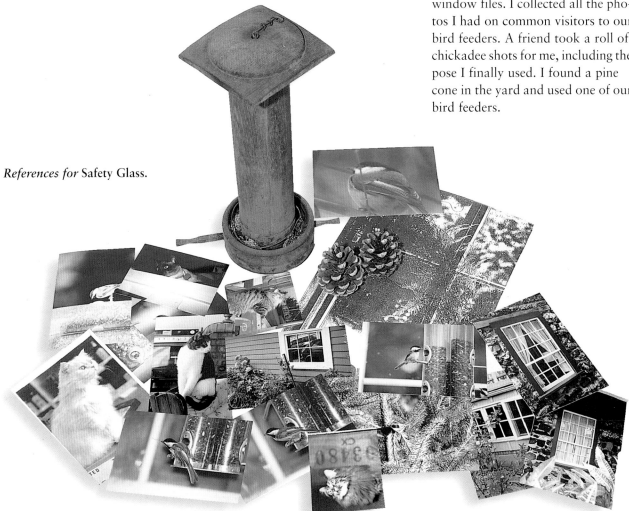

References for Safety Glass.

SKETCH INITIAL IDEAS

I started playing around with ideas—first with rough sketches, then with bits and pieces of the composition drawn on tracing paper so I could move things around, adjust sizes. By juggling the elements of the painting—the cat, the bird, the feeder, etc.—I came to final decisions about their placement and their relative sizes.

Other painting ideas might come from a single experience, someone's suggestion or photos sent by a devoted cat owner. The idea might come to me complete or as a tiny fragment. I might start on it the minute I think of it or put it on my list of "New Ideas" and get to it years later.

Sometimes I'll take a photo, or get one from a friend, that is so perfect I want to use the whole thing in a painting. Often, I'll want to use the animal and make up my own background for it. Other times, I'll find inspiration from one tiny element in a photo.

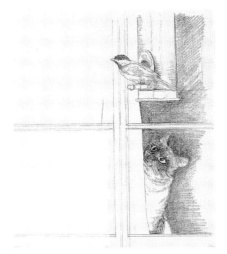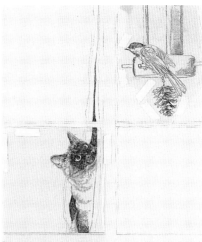

Preliminary Sketches for Safety Glass.

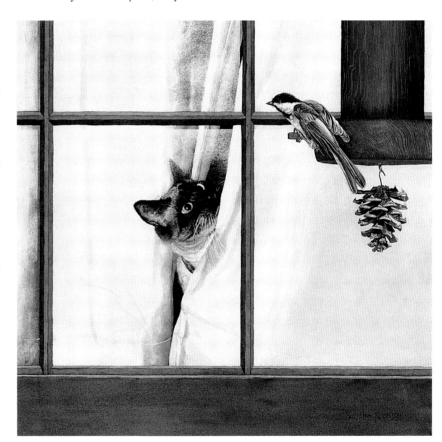

The Finished Painting
In the finished painting, I've enlarged the window and placed the cat closer to the bird. I simplified and enlarged the feeder and moved the bird to its edge (this emphasizes the importance of the "safety glass" to the bird).

Then I designed the curtains. All other decisions were made later, including the one to paint the windowsill dark green, emphasizing its structure and its presence.

SAFETY GLASS
14½" × 15¾"
(37cm × 40cm)

DESIGN ELEMENTS

Some artists design by instinct, and each painting is unique and perfect. For most of us, though, design is a hit-and-miss proposition. We have an idea. It works or it doesn't. We analyze the final result and see that we have unconsciously used design elements to get the proper mood or idea into our work. Here are some of my favorite design elements.

LIGHT AND SHADOW

Light and shadow play an important part in any painting. Find your light source. Where's the light coming from? How dark are the shadows it casts? Do you want softer, diffuse shadows in a pale mauve, or deep, black shadows? Try putting some "theater" into a painting by making shadow its main theme.

SOFT LIGHT

Sometimes you want an overall glow with no shadow in a painting. A well-lit room with multiple light sources or a foggy day and—presto!—no worrying about where the shadows fall. Just be aware that you will want to "ground" your subjects by putting a darker color beneath them, or they will magically levitate, no matter how diffuse your lighting.

LOW LIGHT

Low light is exciting to use. Whether you can see the actual light source or just its effects, you get to use warm, rich color and deep shadow. Remember that all of your colors are lower in intensity as your light source dims.

HEAVY SHADOW

The Oxford English Dictionary describes "chiaroscuro" as "the use of marked light and shade contrasts for decorative or dramatic effect in painting." To get this effect, I sometimes use India ink, which blocks out all light. The effect is stark, very contrasty and very dramatic, like in *Sunspot*, page 43.

MID TO DARK SHADOWS

You can get a softer effect by using watercolor for your shadows and using India ink only for the very darkest parts of them.

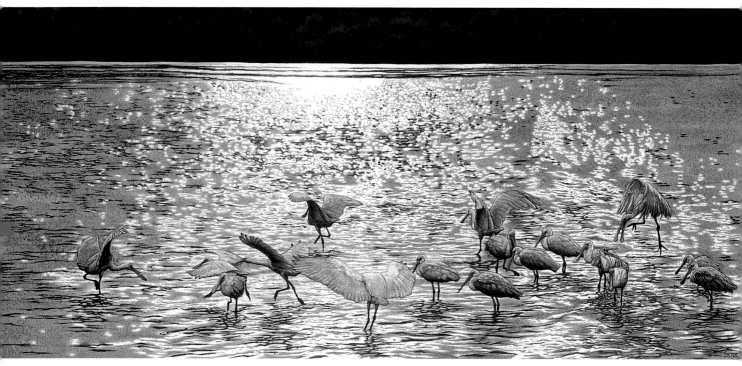

Colors in Low Light
Sanibel Sunset shows the sun going down. As I first painted them, the roseate spoonbills were much too bright a pink. I glazed over them time and again with Charcoal Grey watercolor until they dimmed in color enough to look like they belonged in their surroundings.

SANIBEL SUNSET
13½" × 31½" (34.5cm × 80cm)
Collection of the Leigh Yawkey Woodson Art Museum

YOUR SUBJECT IN SHADOW

When your subject is in deep shadow, try ink for the darkest areas. In *Prairie Dogs* (top right), each stone casts an India ink shadow, as does each animal, helping define the prairie dogs and establish a time of day.

THE COLOR OF SHADOWS

My all-time favorite shadow color is a mixture of French Ultramarine and Burnt Sienna. In *Callie Poolside* (bottom right) you can see the mixture applied as a thin wash on the concrete and heavier in the shadows cast by the chairs. Because the blue and red pigments separate, they form beautiful patterns on the paper. With more French Ultramarine, your shadows are cooler. Add more Burnt Sienna and your shadows are warmer, like those cast on wood, dirt or even terra cotta.

I like using Winsor & Newton's Neutral Tint straight from the tube for purple shadows on snow. Payne's Grey makes a gray-green-blue shadow color and looks great with water or snow.

Shadow Washes

It was early morning at my niece's house. No one was up but me and the cat. As Callie rolled on the warm concrete, the long shadows cast by the patio furniture played over her.

The cat is India ink with a little watercolor. The furniture is a very pale wash of French Ultramarine and Burnt Sienna, glazed over with Quinacridone Gold. Everything else got a wash of a slightly darker mix of French Ultramarine and Burnt Sienna. The final shadow color cast by the furniture is an even darker version of the same blue and red.

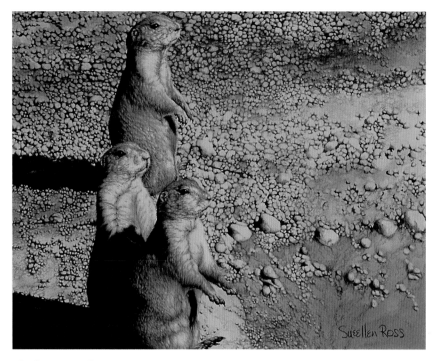

Shadow on Subject

Painted early in my career, *Prairie Dogs* was the first time I used India ink as shadow. Only the very darkest part of the shadows is done in ink. The lighter shadow on each rock is done in Neutral Tint watercolor, and the midtone areas on the dogs are done in Sepia and Burnt Umber watercolor.

Lighter-colored pencil is used to put detail in the inked areas. (See the stones in the shadows behind the dogs.)

PRAIRIE DOGS
13″ × 16″
(33cm × 41cm)

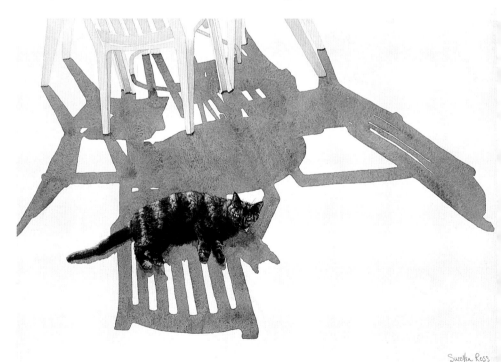

CALLIE POOLSIDE
14″ × 18″ (36cm × 46cm)

REPEATING PATTERNS AND SHAPES

One of my favorite compositional tools is the use of themes. Repeating light/dark patterns, repeating colors, repeating shapes—all of these pull your composition together, giving it more drama and impact. Notice the shapes of the light patterns in *Sunspot*, page 43, and the crescent shapes of petals and leaves in *Daisy Faces*, page 43.

NEGATIVE SPACE

All my earliest portraits of people and animals floated on pure white paper. Without thinking about it, I was making great use of negative space. As my skill as a painter increased, I put more and more stuff in my backgrounds, often confusing the focus of the work and diminishing its impact. Though I still get carried away with detail in some of my backgrounds, I design certain pieces to show off great expanses of nothing, like the pale background in *Killdeer and Beach Grass* (top right) and the dark background in *Chiaroscuro Cat* (bottom right). In each case, the empty space means something; it represents expanses of hot sand or a room in deep shadow. It is not just blank paper. This kind of design zeroes in on your subject and makes a very dramatic statement.

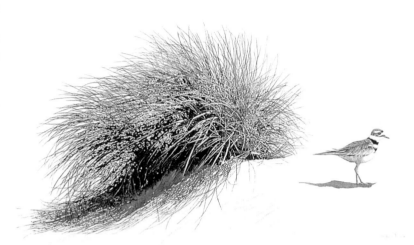

Negative Space: Pale Colors
Killdeer and Beach Grass is a study of negative space. A simple, pale wash of a French Ultramarine and Burnt Sienna mix becomes a whole stretch of beach. Slightly darker parallel strips become ridges of sand.

Your eye spends little time on the background, but the mood is set. All attention is focused on the subject—in this case, a single clump of grass and a lone killdeer.

The shadows unite the design—palest when cast by the ridges in the sand, darker behind the bird and the grass, and darkest inside the grass. (The darkest shadows are done in India ink.)

KILLDEER AND
BEACH GRASS
22½" × 28½"
(57cm × 72cm)

Negative Space: Dark Colors
In *Chiaroscuro Cat*, the negative space represents a dark room and is done with India ink.

The great majority of the painting is flat black ink. Yet your mind assumes that behind the cat and chair exists an entire room—fully furnished at that. Such is the power of negative space.

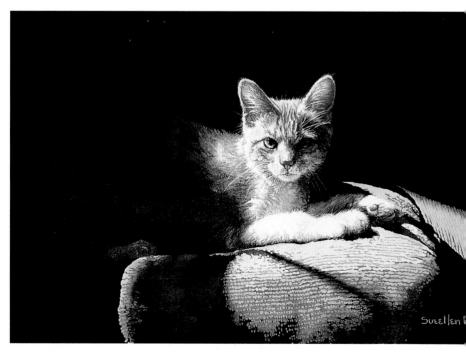

CHIAROSCURO CAT
7⅝" × 11¼" (19cm × 29cm)

UNUSUAL POSES

A few years ago, I specialized in paintings of animals scratching, eating, fighting, doing anything that would not idealize them. What fun that was! Now, my mission as an artist is a bit more relaxed. I paint what I want and don't worry so much about doing unusual poses and being "different." Sometimes I use typical and oft-painted poses.

Still, there is nothing more liberating than painting something outrageous or controversial or bizarre. Just don't plan on printing it and selling lots of copies.

UNUSUAL PLACEMENT OF YOUR SUBJECT

Rules are made to be broken, don't you think? I've done crowd scenes of birds with no focal point. I've put subjects in the top left corners of paintings and cut off legs or even heads of others. Try whatever you like. Take some risks. But remember it's not always going to work.

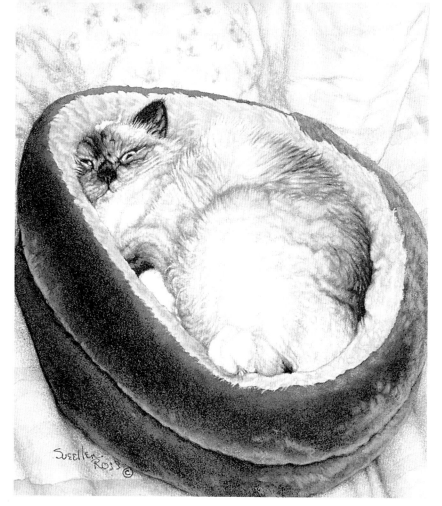

Unconventional Pose

Who wants a picture of a crabby cat? Who wants a painting of a cat crammed into a fake-fur bed? Who wants a painting whose vantage point is looking over a cat's rear end?

The owner of the cat might want it. Someone might want it because it makes her laugh or because it evokes a sympathetic response. Someone might want it *if it is a good painting*. And, this last possibility is the most important criterion I know.

INTERRUPTED NAP
7⅜" × 6¼"
(19cm × 16cm)

HESTON
9" × 20"
(23cm × 51cm)

Where Should the Cat Go?

Heston is rather squashed up against the top of this painting and not much of him shows. It is basically a painting of a creeping vine with little blue flowers.

Why does your eye go directly to the cat? I think the unconventional pose attracts the viewer's attention.

GROUPS

The placement of groups in your design will make or break your composition. I am at a loss to offer rules here, as most of my groups seem to take positions without my stage direction. Not all of my groupings have been good designs or even pleasing to the eye. I just keep trying new things. Some work; some don't.

CAMOUFLAGE

Camouflage is an important element in nature and can spark many ideas for paintings. Though this theme has been quite thoroughly explored in wildlife art for the past several years, it's too important to ignore. It can still be done with originality and charm.

You can camouflage your subjects by partially hiding them among other elements, by echoing their coloring in your background, or by using even more extreme techniques.

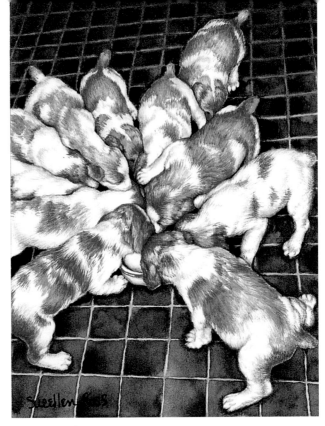

BRITTANY BABIES
9¼" × 7½"
(23cm × 19cm)

Arranging the Group

The composition of *Brittany Babies* is as chaotic as the pups' table manners. Some parts of the pups are cut off; extra pups are jammed in here and there. Only the predictability of the tile floor looks planned.

Many of my "group" paintings are like this, so I have little advice to offer. Just move the members of the group around and try to find the most pleasing design during your preliminary sketches.

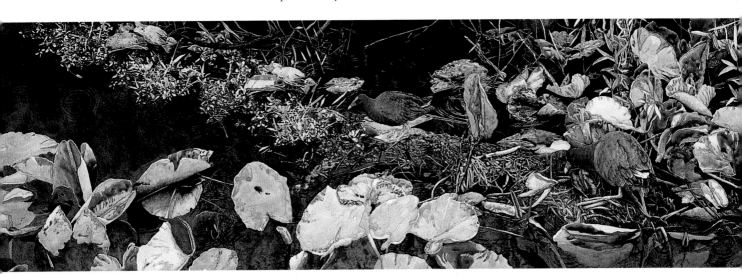

Find the Birds

The only thing that alerts you to the presence of these birds in their natural surroundings is their movement. Their coloration is astounding—electric blue, yellow, bright red, powder blue—yet these iridescent birds match the bright surface of the water, the mossy green of the decaying vegetation and the shimmer of the wet lily pads—all at once!

PURPLE GALLINULES IN THE RAIN
11" × 40" (28cm × 102cm)

ABSTRACT BACKGROUND

Water can look like anything, as can clouds and snow. Why not try abstract patterns of shadows, reflections, waves or shapes in your background? In *Great Blue Heron* (right), I brushed on India ink to make a random pattern of watery wiggles in the background. Because this looked too stark, I added a lot of water to my ink and made a transitional area of lighter watery squiggles. Then I added an even lighter area, using mostly water. I painted over the whole background, ink and all, with Neutral Tint watercolor. And there you have it—shadowy water. Such fun.

Experimenting with an ink-wash background has taught me the following, which I suggest to you:

- Pencil in a general plan for where you want the ink, but don't get too picky.
- Sketch in your subject so you know where the ink *doesn't* go.
- Collect some photos or do some sketches of water patterns for inspiration.
- Relax, dip your brush in the ink and go for it!
- Try softening the effect with an extra wash or two of diluted ink. (*Great Blue* has three values of ink.)
- Try using watercolor on top of all inked areas.
- Try using colored pencil on top of the inked areas and using watercolor for extra reflection and/or color.

Wait until you are in an adventurous mood to try this abstract background design element, and don't invest a lot of time working on your main subject first. Just go for it. If

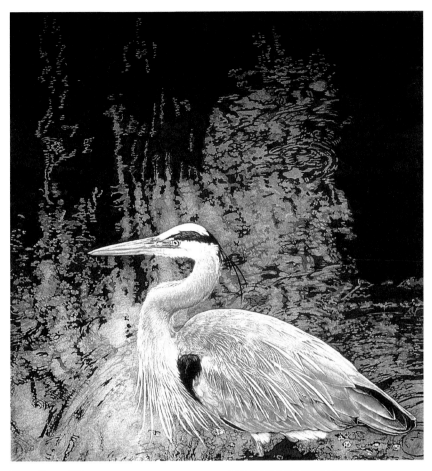

Free-Form Water
Great Blue Heron was my first attempt at an abstract ink wash as background. I liked the look so much that I've tried it several times since, with mixed results.

GREAT BLUE HERON
16″ × 14″ (41cm × 36cm)

you like the results, then you can go ahead with the rest of your painting.

These are a few of my favorite design elements. I'm sure you can think of many more you'd like to try. Just remember, with the mixed-media technique shown in this book, you must decide on and commit to the design at the beginning, in the drawing step of your painting. Once you put ink to paper, your design is set; there's no going back.

MIXED-MEDIA TECHNIQUES

A four-step program—sounds vaguely familiar, doesn't it? In this chapter, we'll take two paintings through each of these steps—drawing, inking, watercolor and colored pencil.

Each painting I do contains every one of these steps. The steps are unchanging. Everything *else* changes from painting to painting, but not the steps.

The best thing about breaking a project down into steps is that you only have to take one at a time. If you do the very best job you can on the step facing you, the final painting will be just that much better. If you are careless about composition or don't work out your light source before you start inking, you're not going to be satisfied with the piece, no matter how beautiful the watercolor and colored-pencil steps that follow.

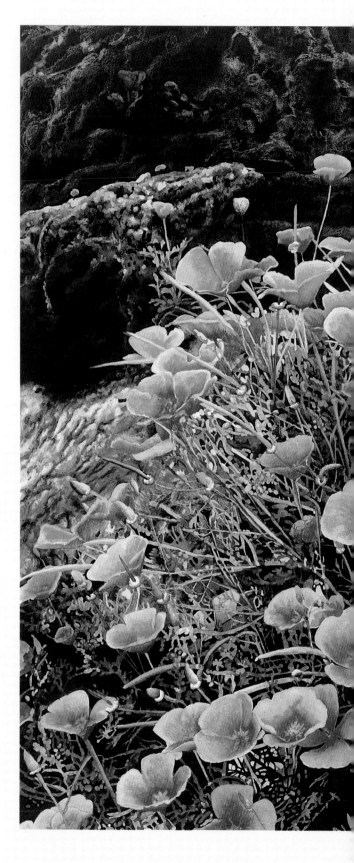

SUMMER GOLD—VARIED THRUSH
14½″ × 21¾″ (37cm × 55cm)

A Blast of Heat and Color
A blast of heat and color hits the Pacific Northwest every August. It is my favorite time of year, and this painting is my tribute to it.

Summer Gold uses just about everything in my bag of mixed-media tricks: colored pencil drawn on top of India ink (bird feathers and rocks in background); ink with areas left open for watercolor and pencil (flowers, orange on bird); Warm Grey Acrylic with Burnt Umber watercolor (light areas of foreground rock and pebbles).

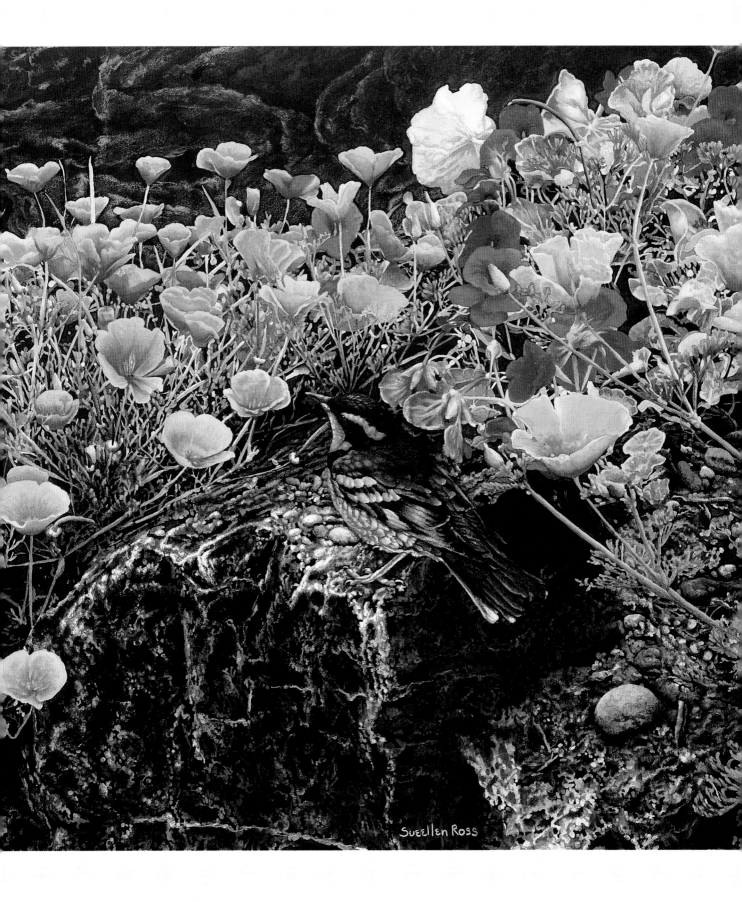
Sueellen Ross

DEVELOP IDEAS AND ESTABLISH A DESIGN

IDEAS

Start simply. For your first mixed-media painting, pick a subject you love. Use your personal style; make the painting yours.

Pick a high-contrast subject so you can take advantage of the full range of black to white that India ink gives you. I chose two very high-contrast subjects for the step-by-step paintings in this chapter to show you the depth and intensity you can get with this technique.

Both paintings are based on photographs given to me by students. Each has large, dark background areas calling out for India ink. Each has bright, light areas that translate into pale watercolor or use the white of the paper.

DESIGN

A good design can be separated into foreground, midground and background. Find your central subject, place it where you want it in your composition and adjust everything else in your composition to serve the purposes of your main subject. Throw out anything and everything that does not add to this end.

Compose with dark and light areas in mind. Use your eye as a color separator. What will be the darkest parts of your composition? Those you will fill in with India ink. What will be the lightest? These will be areas of white paper or white pencil.

The patterns of light and dark in your painting are influenced in a major way by your light source. Try to figure out how strong your light source should be and where the shadows will fall. This is not as easy as it sounds, unless you are working from photographs that spell it out for you. I've gotten into some real pickles by waiting until a later stage of a painting to make these decisions.

You can always cheat and say it's a foggy day or have an indoor subject evenly lit by multiple light sources. But dramatic lighting is such fun using this technique that I encourage you to take advantage of it.

Take time to work out everything now. Once the ink is on, you won't be able to change your mind. Do not get bogged down in detail on this project; it will slow you up and frustrate you. If you are a detail freak like I am, you can add them to your next project.

Preliminary Sketch for Sunspot *(page 43)*
Preliminary sketches and drawings, done in an erasable medium (such as an HB pencil), can help you make some important decisions up front.

In this pencil sketch for *Sunspot*, divide the composition into a definite foreground (those areas hit by a single beam of light), midground (the cat, pillow and chair in shadow) and background (the blank area to the left). Tonal values become clear. The design is made dramatic by the lighting, which illuminates the cat, the top of the pillow and the arm of the chair.

Preliminary Sketch for Daisy Faces *(page 43)*
If you are working from photographs, as I am here and in *Sunspot*, the question is often what to eliminate rather than what to add.

I planned the background in *Daisy Faces* to be India ink, with background vegetation drawn directly on top of the ink. However, after doing this preliminary sketch, it looks like the background will be much too dark. In order to emphasize the vegetation, leave more areas free of ink and paint them with watercolor. This decision must be made before the ink stage.

Preliminary sketches are working drawings that help address concerns about your composition.

DRAW A MAP OF YOUR PAINTING

Your love of drawing probably made you reach for this book. For those of you who are comfortable with translating your preliminary ideas and sketches into a pencil drawing, this step will be a breeze.

Tape the four corners of a small-ish piece of 140-lb. (300gsm) Arches or Lanaquerelle hot-press paper onto a smooth, stiff board. Taping just the four corners allows you to lift and stretch the paper as needed. Draw directly on this good paper with a graphite pencil. (If you find that erasing and overworking your drawing damages the surface of the paper, you might want to try the tracing paper technique explained on page 17.)

The drawing technique for mixed-media paintings is different from charcoal or Conté pencil drawing. For mixed-media paintings, drawings do not have to be beautiful in themselves. Consider them maps or outlines that show you where to put the ink, where to put the watercolor and where to leave the paper white.

Select the areas of the painting that will not be black, and use clean, crisp graphite pencil lines to outline these separate areas; no shading is necessary. The areas that will be covered with ink should be left blank.

LEARN HOW TO DRAW

Are you just learning how to draw? Consider taking a beginning drawing class at your local community center or college. There is no better way to get started, though a good book on learning to draw is a strong second. Do not expect too much of yourself at the beginning. Pick a simple subject for your first project.

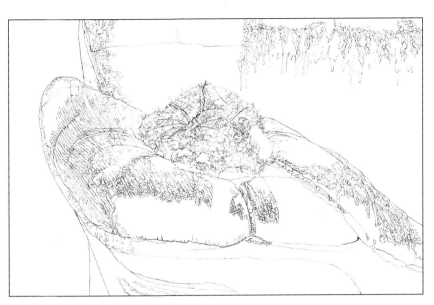

1 Create a Map
SUNSPOT
Concentrate on outlining the texture of the kitten's fur and whiskers, the texture of the part of the armchair that is hit by light, the pattern of light and dark on the pillow behind the cat and the fringe on the shawl in the background. All the rest of the painting will be very dark, so don't bother developing it further at this stage.

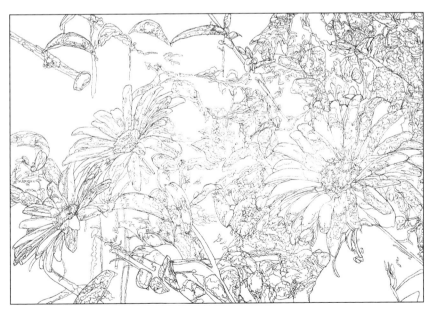

1 Create a Map
DAISY FACES
This is your chance to decide what large flowers should be free of ink to form the foreground, what smaller flowers, leaves and stems should be free to form the midground, and what, if any, small leaves and stems should be left as background.

Outline each area of color where the shadows fall on the flower petals and where the highlights brighten the leaves and the stems. If you want to put a lot of detail into your painting, this is the time to do it.

LAY THE DARKEST VALUES WITH INK

Using ink in the way I will describe here gives your work a very different look. The darkest value in your painting is created with India ink. This is not a pen-and-ink drawing with paint on top of it. This is not an outline in ink. This is a real painting, with a tonal range that goes all the way from white to black—and the black is India ink.

In general, the darker your painting, the more ink you will use. Some paintings will have lots of ink, like *Daisy Faces*. Some very dark paintings, like *Sunspot*, will have even more ink than watercolor. Some paintings will be light and delicate and will have very little ink. But each painting will have ink as its darkest value.

The more detailed your drawing, the more inking decisions you'll need to make. *Sunspot* has large blocks of ink in the background, but very little on the subject. In *Daisy Faces*, everything is India ink except a few flowers, leaves and stems.

GET CREATIVE

The inking in *Sunspot* and *Daisy Faces* is pretty straightforward. However, India ink can be used in so many creative ways. In addition to using it to black out your darkest areas, you can use stippling (random dots) for black-tipped fur, cross-hatching (a grid of crossed lines) for mesh, thin lines for boat rigging and watered-down ink washes to make a tonal painting underneath your color.

Use ink for the pupils in eyes, for silhouettes, for the negative spaces between blades of grass and leaves, for patterns in stone and for the very deepest parts of shadows.

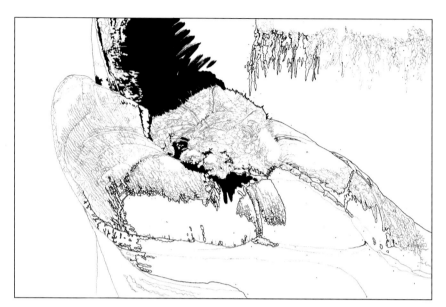

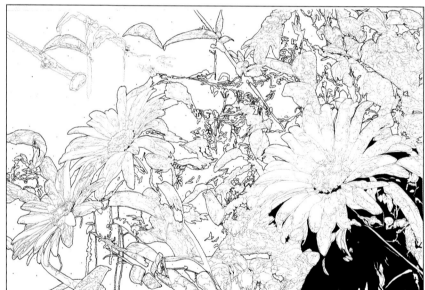

2 *Outline With Ink*
SUNSPOT/DAISY FACES

Once you are satisfied with your design, use your drawing and source materials to decide which areas in the composition have the darkest values. I call this "using your eye as a color separator." Separate your subject into darkest darks (which you will fill in with ink) and lighter areas (which you will color in with other media).

Once you've decided where you will use ink, use a waterproof ink pen to mark those areas with a dot or little hatchmark. This is your inking map. It should keep you from inking the wrong places. Then, use your pen to outline each marked area. The pen gives you more control and precision than a brush. In the paintings above, I have started to fill in some of the darkest areas with ink.

A FEW WORDS OF CAUTION

Ink is permanent. This is great for the watercolor stage and for artistic purposes, but not great for clothes, the rug or the cat that knocks an un-capped bottle off the table. (I know.) So, keep your ink pot capped while not in use, and be careful with your elbows. The only way to remove India ink from paper is with a craft knife. This must be done carefully on small areas only, as it will damage the surface of your paper, making additional painting steps difficult.

Clean your inking brushes as soon as you've finished inking. If you forget to, they'll be stiff as boards; however, they can easily be brought back to life with warm water and soap.

Think before you ink. Ink blocks out all light and color. Don't get carried away and overuse it. Squint at your source materials to determine only the very darkest values.

Apply ink in thin coats. Don't puddle it on, or it will leave shiny lumps when it dries. If your wash of ink looks uneven and blotchy, wait until it dries and then add a second coat to even it.

WARNING

Ink is applied underneath water-based media. If you use ink that is not water-proof, you will ruin your painting.

3 *Fill in Ink Shapes*
SUNSPOT/DAISY FACES

Fill in all your darkest areas with undiluted India ink. Remember that you're not drawing with the ink, nor are you outlining objects. Designate your darkest areas and block out all the light in them with ink.

You can use an ink pen for small areas and a brush for larger areas. Just don't use the brush for anything but ink afterward, as it may pollute your colors. I use a Princeton no. 6 or 8 brush to apply most of my ink. If you accidentally black out the wrong areas, either change your painting design or start anew.

ENLIVEN YOUR PAINTING WITH WATERCOLOR

Nothing is more beautiful than transparent watercolor. You really can't overdo this step, so live it up! Cover as much of the painting as you can with watercolor, leaving only the highlighting and final detail to the colored pencil step to follow.

APPLYING A WASH

Flat Wash

A *flat wash* is an even application of watercolor over a significant area of paper. A wash applied directly to dry paper is called *wet-on-dry*. A wash applied to wet paper is called *wet-on-wet*. The first will create stronger color, but it's more difficult to apply evenly.

Both wet-on-dry and wet-on-wet washes are applied in a similar fashion. Mix a large batch of watercolor, and test it first on scrap paper to make sure it is the color you want when it dries. Then tape your watercolor paper to a board. Tilt the board by placing something under the top of it, so that when you apply color, it will run down the paper. Fill your largest watercolor brush with paint, and brush an even line across the top of the paper. Fill your brush again, and paint another line directly under the first, catching the bead of extra paint that has formed at the bottom of the first line. Leave no gaps. If you continue to do this all the way down the page, filling your brush with paint before each stroke, you should have an even wash. If your paper is evenly damp before you apply your wash (wet-on-wet), the paint will disperse more freely and evenly.

Graded Wash

A *graded wash* is achieved when instead of adding more paint to your brush with each stroke, you add water, diluting the paint already in your brush with each application. A graded wash is a beautiful thing to behold, but not particularly easy for beginners to accomplish.

GLAZING

I love piling transparent layers of one color on top of another. This is called *glazing*, and it results in colors so complex and beautiful that they could never be captured in a single tube. Transparent glazes of color over color make for spectacular effects, but success depends on the skill of the watercolorist and the individual attributes of the selected colors. You can easily make mud by combining the wrong pigments or by not letting your paint dry thoroughly before the next glaze color.

I've never been much for rules, which means that I make a lot of mistakes. By not memorizing which pigments are transparent and which are opaque, by not taking the time to find out why the charts say this color stains or that color vanishes when glazed over, I try things that defy the rules. I've tried opaque glazes over opaque washes and found that if they don't turn to mud, they can be quite wonderful. I've watched a carefully applied wash disappear under another layer of color, only to re-emerge, when dry, in the most remarkable patterns.

Painting a Wash
To help ensure a successful watercolor wash, be sure to mix up enough paint; you will not want to run out. Fully load your brush with each stroke, and don't try to go back and fix anything.

Flat wash Graded wash

Glazes—French Ultramarine, then Winsor Red, then Burnt Sienna

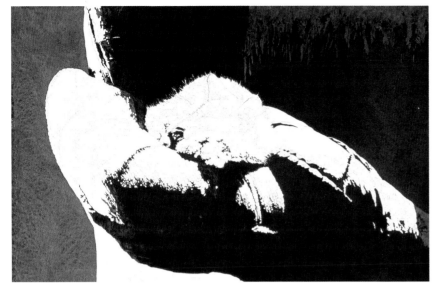

4 Paint Darkest Areas
DAISY FACES

Wash a medium-dark shade of Charcoal Grey over the entire ink background to eliminate shine and to give the surface tooth. This painting does not have any really large areas of watercolor, so start adding color by selecting your darkest values.

Paint the darkest greens with a mixture of Hooker's Green and Sepia. It should be almost as dark as the ink.

Paint in the darkest values of the daisy centers with a heavy application of Quinacridone Gold.

Look at your reference material and separate out darks and lights. What is the darkest color? That becomes India ink. The next-ligher color? That's the dark greens of the leaves and stems in *Daisy Faces*. The next-lighter color? Continue all the way up to the lightest color, which in *Daisy Faces* is the white of the paper in the foreground daisies.

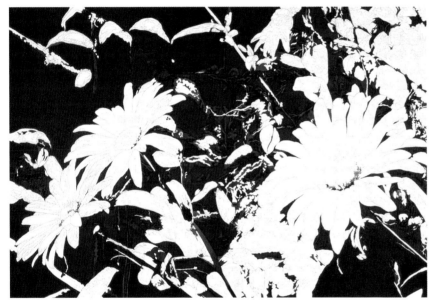

4 Paint Darkest, Largest Areas
SUNSPOT

Mix a big puddle of Charcoal Grey watercolor to a medium-dark gray shade. Wash it over all the ink. This cuts the ink's shine and gives it more tooth to accept colored pencil later. Paint it in the shadowy areas of the pillow.

Next tackle the largest watercolor wash. First paint the large, shadowy, flat area on the left, using a fairly dark French Ultramarine/Burnt Sienna mixture to help it recede.

Then, working from dark to light, select your colors and fill them in. The shawl on the upper right, for example, is even darker than the area on the left, and gets an even darker mixture of the French Ultramarine/Burnt Sienna mix.

Paint a strong concentration of Neutral Tint on the darkest parts of the chair.

Detail of Pillow—Sunspot
Underpaint with Charcoal Grey watercolor to create very dark, shadowy areas. It is the next-lighter value of your painting (after ink).

COLORS

WATERCOLOR
Aureolin
Burnt Sienna
Burnt Umber
Charcoal Grey
French Ultramarine
Hooker's Green
Neutral Tint
New Gamboge
Quinacridone Gold
Raw Umber
Rose Doré
Sap Green
Sepia
Warm Grey Liquid Acrylic
 Color
Winsor Red

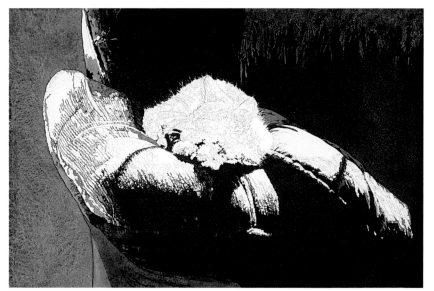

5 Paint From Dark to Light
SUNSPOT

Build your painting one color at a time, getting lighter and lighter as you go. Pick out the next-lighter areas of the chair and paint them in with a lighter concentration of Neutral Tint. Then add some water to your paint and do the next-lighter shade. (There are three shades of Neutral Tint in this stage.)

Add the deep green of the pillow using a mixture of Hooker's Green and Sepia. Paint this mix right over the Charcoal Grey shadows at the far right.

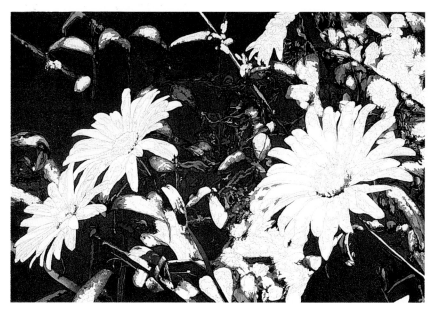

5 Paint Lighter, Brighter Greens
DAISY FACES

Paint the lighter green foliage using increasing amounts of Aureolin mixed with Hooker's Green; the lighter the paint, the warmer it looks. (The occasional pale bluish leaf of unmixed Hooker's Green is an attractive exception.) Moving from dark to light, add a little yellow and a little more water for each of the four shades of green in this stage. Always concentrate on one shade at a time—the darkest—and when you've put in all you need of that shade, proceed to the next-lighter one. The task will seem less daunting if you take it one shade at a time.

To provide relief from all those greens, use a heavy application of Burnt Umber to show the warm browns of dried leaves and stems.

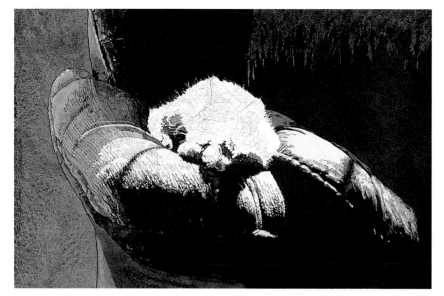

6 Develop Background, Start Subject
SUNSPOT

Apply three more shades of Neutral Tint on the chair and three more shades of the green mix on the pillow, adding a little more water each time. The watercolor in your background is now done.

Next, concentrate on your subject. Select the darkest shadow areas on the cat (almost as dark as the ink) and fill them in with dark Charcoal Grey. Then, paint in a slightly lighter wash of the same. You are beginning to build a *grisaille* (a gray underpainting that establishes values).

Detail of Pillow—Sunspot

After you've put in your greens, glaze over the whole pillow with a very pale mix of Hooker's Green and Sepia. Notice that the edges soften when you glaze over the greens. You can increase that effect by lightly scrubbing these edges with a brush while the glaze is still wet. After scrubbing, lift the excess paint by blotting with a tissue (see page 38 for more information on scrubbing).

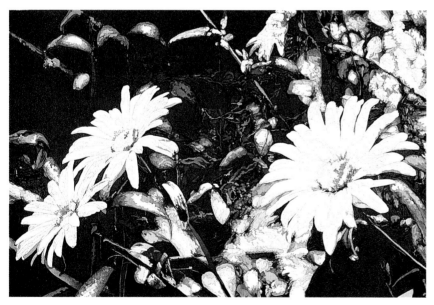

6 Develop Greens and Subject
DAISY FACES

Introduce beautiful Sap Green to your mid-greens here. For more olive areas, add some Burnt Sienna to your mixture. For brighter yellow-greens, add some yellow. (Aureolin with just a bit of Sap Green makes a brilliant new-growth green.) Test all your greens on *scrap paper* before using them.

Apply more Quinacridone Gold to the centers of the daisies, going just a bit lighter than the first, dark application.

The darkest shadows on the daisies go on now. Use Charcoal Grey with enough water to make a medium, silvery gray. Test the color to make sure it's not too dark or light.

GETTING AND SAVING WHITES

PAPER

In *Daisy Faces*, the white of the flowers is actually the paper. Because the white flowers are surrounded by India ink, it is easy to keep their edges sharp by drawing around the petals with a rapidograph pen.

MASKING FLUID

If the background of *Daisy Faces* had to be painted with watercolor, the job would have been much harder. Trying to keep a nice, even watercolor wash going while painting around each petal, stem and leaf is beyond my skill level. Had that been the case, I would have protected the flowers, leaves and stems by applying a liquid rubber solution called *masking fluid* (also called *Stop-out*, *Friskit* or *Maskoid*, depending on the brand). I use Incredible White Mask. Since masking fluid ruins brushes, apply it with a tool called The Incredible Nib (see "Tips on Using Masking Fluid" below).

WHITE PENCIL

You can also achieve white by using a wax-based pencil as a resist, instead of using masking fluid. To make soft, clean whites on fur, feathers or any other texture, use White pencil along with Winsor & Newton's Warm Grey Liquid Acrylic Color and a wash of Burnt Umber watercolor.

First, select the lightest areas of your subject. Keep these areas white by covering them completely with White pencil. Then apply a wash of diluted Warm Grey acrylic over the whole subject. You now have two colors—a pure white and a light pearly gray. Select areas where you want the light pearly gray to stay, protect them with White pencil and apply another wash of Warm Grey acrylic. Now you have three colors. You can do this as many as eight or ten times, depending on the complexity and shape of your subject. In this way, you can create a whole tonal range of white through warm mid-gray without ending up with a dirty-looking mess.

After applying all your shades of gray, wash over the whole area with Burnt Umber watercolor, diluted to a pale, warm golden brown. It soaks into the Warm Grey acrylic areas not protected by waxy White pencil. In a way that I don't fully understand, the Burnt Umber combines with the Warm Grey and gives it life.

When the Burnt Umber is dry, erase the whole area down to the paper. This gets rid of all the extra paint that may have puddled on top of the White pencil, all the White pencil and all the graphite drawing underneath.

I stumbled onto this method by accident several years ago and have been using it, at least to some extent, in every painting I do.

TIPS ON USING MASKING FLUID

I use masking fluid only when the design of my painting forces me to. Here are some tips I have learned the hard way:

- Always have a jar of warm, soapy water handy. Dip your nib or brush in it frequently to remove the hardened material.
- Clean your nib or brush immediately after using.
- Use an old brush to cover large areas with masking fluid, and don't use it for anything but masking fluid thereafter.
- Don't put mask on wet paper, and don't paint over it until it is absolutely dry. If paper and paint are wet, mask will sink into the paper fibers and paint pigments instead of staying on top, and the paper or paint will come off with the mask when you remove it.
- Never dry mask with a hair dryer; you'll bake it permanently into the fibers of your paper.
- Remove mask with a "masking fluid remover" (a small, rubbery white square that removes your mask without taking too much paper with it). Remove the mask carefully, and don't leave it on your paper any longer than necessary, as it has a tendency to leave a slight yellowish stain if left on for long periods of time.

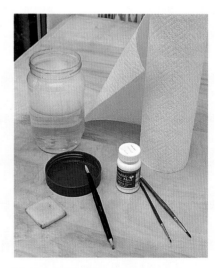

Masking Fluid and Supplies
Apply masking fluid with an Incredible Nib or with brushes reserved exclusively for this purpose. To remove the masking fluid when it's dry, use masking fluid remover (lower left).

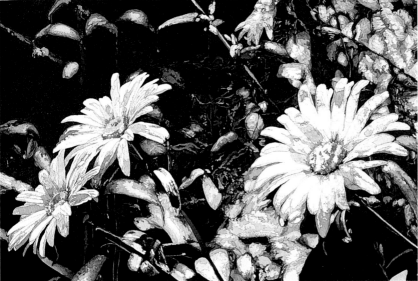

7 Finish Leaves, Develop Shadows
DAISY FACES

Paint in the final leaf colors with pale yellow-green (Aureolin with a touch of Sap Green, very watered-down) and use pure Aureolin for the lightest, brightest spots.

Highlight the daisy centers with pale Aureolin where the sun would strike most brightly.

Sunlight coming from the top left casts strong shadows on the daisy faces. The deepest shadows, which you've already done in ink and with the first application of Charcoal Grey, are in the middle of the flowers, where the raised centers hide the petals from the light.

Now put in paler shadows in areas where the light doesn't reach. Add three more grays, using lighter shades each time. The first is Charcoal Grey (add more water to it than you did for the darkest petal shadows). For the next two lighter grays, switch to Warm Grey acrylic, which is warmer and paler than the Charcoal Grey. Mix water with the acrylic and test the color for the proper lightness.

The paper provides the lightest color on the foreground daisies—pure white. Make sure this area stays clean and free of paint. It will soon look even crisper when you have erased all the graphite pencil.

7 Build Shadows, Save Whites
SUNSPOT

One small kitten will show you the two most important techniques I use: a grisaille to create shadowed areas and white pencil to save whites.

To create a grisaille, paint several more gray values with Charcoal Grey watercolor, working from dark to light. You have already applied ink and two dark grays on the kitten. What are the next lighter areas? You might find it helpful to mark the next-lighter areas with a dot of color to ensure you don't paint in the wrong areas. Here (and in step 7, *Daisy Faces*) I use a Light Ochre water-soluble pencil to mark these areas. It will show up enough to see, but it will dissolve with the next layer of water-based paint.

Paint in your next-lighter areas with a small brush and Charcoal Grey diluted with a little more water than you used the last time. Look at it again; what are the next-lighter areas this time? Add more water to the gray watercolor and paint them in.

The tricky part is painting around all those whiskers; they should stay white.

Notice where the sun hits the kitten's neck, ear tips, top of head and feet. Fill in these areas solidly with Sanford Prismacolor White pencil. Then wash some diluted Warm Grey acrylic over the whole cat except for the darks. The white pencil you have applied will protect the lightest areas as you start adding more color to the cat.

MARKING YOUR NEXT COLOR

To save time and to avoid mistakes, you marked your drawing with ink dots. These dots showed you where to apply your ink.

You can do the same thing with watercolor. Select the areas that will get the next-lighter color. Mark them with a water-soluble colored pencil. If you select a pencil similar in color to the watercolor you are about to use, it will not show. A Light-Ochre water-soluble pencil works well.

LAST-MINUTE WATERCOLOR ADJUSTMENTS

The major work on your painting is now done, and it's time to step back and see if any adjustments need to be made.

Does the background stay in the background? I thought not in *Daisy Faces*, so later I added another wash of shadow color over everything except the extreme foreground. The shawl in the background of *Sunspot* also needs to be darkened, but I opted to do it with Black colored pencil instead of watercolor so I wouldn't risk muddying an already dark watercolor wash.

SCRATCHING

Sometimes nothing will do but to scratch off some areas with a craft knife. Make sure it's sharp. I once punched a hole in an already-sold painting with a dull blade. Go slowly, do a tiny area at a time and don't expect a watercolor wash to go on smoothly over the scratched spot.

SCRUBBING

When I've done everything I can do with watercolor, I start scrubbing it. I soften edges, highlight and lift paint—all with a favorite, beat-up watercolor brush, some water and a paper towel. Some pigments don't want to let go, but you can lighten or lift almost any pigment if you're willing to take a little paper with it. The surface of my paper often looks like felt when I'm through, and sometimes I wish I'd stopped the abuse a bit sooner. However, over the years I've found this to be a very satisfying way to get more softness and light into my paintings. (Especially since my skills as a wet-on-wet watercolorist are elementary.)

Pale areas often benefit from a scrubbing to soften and lighten their shadows. The curtain in *Safety Glass* (page 19) was scrubbed within an inch of its life.

ERASING

We're all done with the watercolor, now. It's time to erase every little bit of the graphite drawing that we can manage. Use the white plastic eraser; it's easy on the paper. Don't worry about the watercolor. The great majority of it will stay put. Now you get to use your colored pencils.

ADJUST WITH COLOR

If an area of vegetation pops out too much and looks too bright, tone it down with a Payne's Grey glaze. If an area needs to recede, use a glaze of shadow color, perhaps French Ultramarine and Burnt Sienna or maybe Neutral Tint. Also, a neutral glaze of Charcoal Grey might do the trick.

8 Final Watercolor Touches
SUNSPOT

Do you see anything that needs adjusting? Do it now. Add color to the cat. The best red fur color I've found is New Gamboge mixed with Burnt Sienna. My favorite pink for noses and ears is Raw Umber mixed with Rose Doré. (If you don't have Rose Doré, substitute a bit of Burnt Sienna.)

Paint the red right over the top of your grisaille; it will not cover those areas you've protected with white pencil. The strongest, darkest red is in the shadowed areas, like under the right ear and on the nose. Since the cat is striped, add a darker, less diluted red mix to the tabby markings.

Put a bit of peachy pink (Raw Umber/Rose Doré mix) in the ear, on the tip of the nose, and on the pad (right front foot).

Finally, glaze over the gray shadow areas that didn't get any red (like the feet and the white ruff around the neck) with diluted Burnt Umber watercolor, and see the white fur glow.

Now, erase the whole thing with a white plastic eraser, getting rid of the graphite pencil *and* the white pencil.

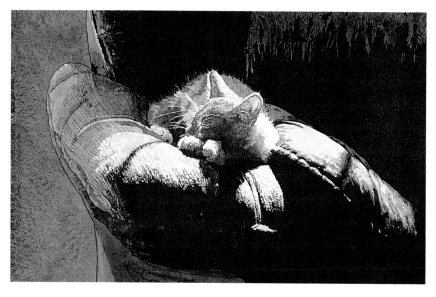

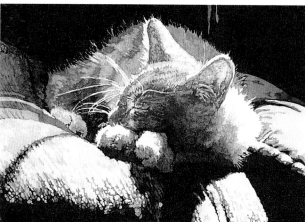

Detail of cat from **Sunspot.**

8 Final Watercolor Touches
DAISY FACES

Fill in the midtones in your daisy centers with some New Gamboge mixed with a little Burnt Sienna.

Mix up a batch of Burnt Umber watercolor, adding enough water to make it a pale, golden brown. With a no. 6 or 8 brush, paint over all of the gray flower shadows with the Burnt Umber, and look at them glow.

Step back, and make final color adjustments before you erase the whole painting and remove *all* graphite pencil from the light colors.

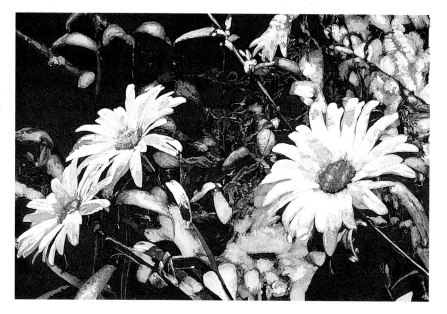

ENHANCE AND DETAIL WITH COLORED PENCIL

Colored pencils can drive you crazy. The points break or get dull almost instantly. The pencils crumble just when you need them to hold up. They smear. They create sticky dust that clings to the dark places on your painting, often going unnoticed until your slides are developed. The wax in them eventually comes to the surface, creating a whitish "bloom."

So why do I love colored pencils so much? Because I am hooked. I put up with them because I love gooey, rich colors, and I love precise, clean line work.

Nothing beats colored pencils for fluffing up the fur on a cat or creating downy plumage on a bird. Nothing beats colored pencils for punching up the deep reds in a geranium or adding gloss to a shiny dark leaf or creating iridescence on the black head of a duck.

Use colored pencils to enhance everything you've already done with ink and watercolor. Use them to highlight, to backlight, to shine, to soften. Use them to warm or cool, to darken or lighten, to soften edges and pull out detail.

RICH COLOR

To get rich color from colored pencils, all you have to do is press hard. The more pigment that ends up on the paper, the richer the color. The pencils are warmed by the friction against the paper, which makes them blend better, too. With enough pressure, your colors will look almost like oil pastels.

KEEP THEM SHARP

My electric pencil sharpener probably uses as much electricity as the refrigerator; it runs constantly. But for an extra-fine point or when you're away from your pencil sharpener, nothing beats a bit of sandpaper. (You can buy little wooden paddles with multiple layers of sandpaper stapled to them. They're likely to be in the drawing section of your art supply store.)

If you want thin, even lines, roll your pencil back and forth a bit as you draw, and your point will stay sharp indefinitely.

GLAZE ON COLOR

Your painting already has an incredible, three-dimensional structure. You've used graphite, ink, watercolor, acrylic and some white pencil. When you add a layer of colored pencil on top, it enhances all that structure *and* adds color.

Glazing with pencil means evenly coating an area with color. You can apply it with slashing strokes or little circles or with any repeating pattern to get an even color. It takes a little practice. However, if you keep going over the area, the color will eventually become even. If you press hard, you'll get a deep color. If you don't, you'll get a paler version of the same color.

I especially like the effects of glazing with dark colors, and I often smear black pencil over an area to knock it further into the background. I can cool an area down with a thin glaze of black or make it almost disappear with a thick one. It is very important to polish and spray these dark glazes, as they are very prone to bloom (see page 42 for more information on "bloom").

Colored-Pencil Aids
An electric pencil sharpener is such a time- and effort-saver that I consider it an essential. The white plastic eraser and the sandpaper-on-a-stick belong on the "essentials" list too, and the pencil extenders will save you money by allowing you to use each pencil down to a stub. The electric eraser is more of a luxury item. (This one's a Sakura, and I like it very much.)

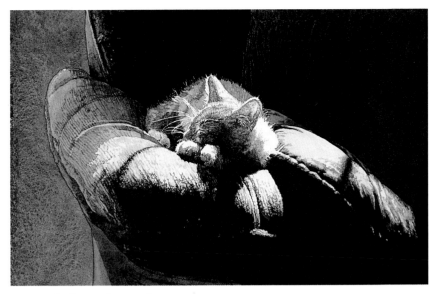

COLORS

COLORED PENCIL
Black
Cream
Crimson Red
Goldenrod
Light Umber
Olive Green
Orange
Sepia
Slate Grey
Spring Green
Tucsan Red
White
Yellow Ochre

9 *Finish the Background*
SUNSPOT

Starting with the background, use some scrap paper to cover up the areas you're not working on, so they won't get smeared accidentally.

Add shadows and details to the shawl with Sepia and Black pencils. To push the shawl further into the background, glaze with Black. Do this lightly at first. If it needs more, do another light coat and keep going until it recedes enough.

Soften the transitions between the ink and the gray-blue on the chair by smudging some Black and Slate Grey pencils over the harsh edges of the ink to soften them.

Soften the transitions between the ink and the green of the pillow with the same technique, using Black and Olive Green pencils, or Faber Castell's Juniper Green.

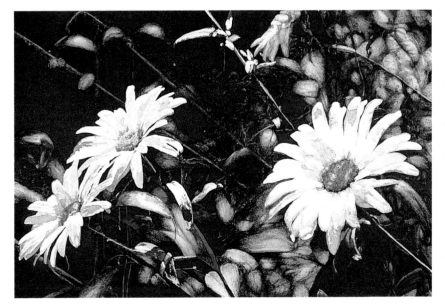

9 *Finish the Background*
DAISY FACES

The background needs to be pushed back further, so separate the background from the foreground with a final glaze of shadow color—a medium-light mixture of French Ultramarine and Burnt Sienna watercolor. Paint over everything except the three daisies and their accompanying stems and leaves.

Emphasize the highlights in your background with White pencil, adding extra details with highlights of Spring Green pencil. Soften your leaf edges with Olive Green pencil and your flower edges with Sepia pencil.

Is your background still too light? Using Black pencil, glaze over those light areas until they recede far enough. If the Black looks grainy, polish (see page 42 for instruction on this technique) and/or erase to smooth out the color.

MAKING COLOR ADJUSTMENTS

BURNISH

Burnishing means adding a new color to an area and pressing hard enough with your pencil to smooth out, polish and blend the new color with those already present. The result is a rich, smooth color that looks more like oil paint than traditional colored pencil.

When you glaze with colored pencil, you are just coating an area of your painting with a new color. When you put down a layer of colored pencil over another and press down hard enough to blend the two layers and polish them, you are burnishing.

SOFTEN EDGES

No matter how dark your watercolor, the hard edge of your inked areas will show through. If you want to soften these edges, select a colored pencil with some black in it, like Sepia or Olive Green, to smooth the transition from ink to watercolor. Most of the time, the colors right next to an inked area are also dark, so black pencil might do the trick.

SHARPEN WITH DARKER COLORS

If an area of watercolor looks flat or needs punching up, try adding detail, shadow and sharpness to it with colored pencil of a deeper, richer hue. A very deep color like Indigo or Tuscan Red can be used to sharpen edges, to shadow and to give depth to an area of watercolor or pencil. For example, Indigo is great for detailing blue eyes, and Tuscan Red is my favorite shadow color for red flowers.

DETAILS—*DAISY FACES*

PREVENT "BLOOM"

The wax in wax-based colored pencils comes to the surface and creates a white film called "bloom." This is especially noticeable with dark colors. However, if you polish the surface of your pencil work, and then spray it with Krylon Workable Fixative, you will never have this problem. To polish, gently buff the colored-pencil painting surface using a Q-tip for tiny areas and paper towels for larger ones. Try not to smear one color over another.

Scrubbing Watercolor Edges
Once you've applied your ink and watercolor and erased all traces of graphite pencil, use a wet brush to gently scrub any leaf edges you want to soften. Blot the area with clean, dry tissue to lift the paint as you scrub. This may take a bit of time, but the effect can be luminous.

Glaze With Colored Pencil
The front leaves will pop forward if you highlight them with White pencil. Soften all ink edges with Olive Green pencil. Shade background leaves with Black pencil blended into Olive Green. Correct the confusion between foreground and background leaves by defining leaf edges with Black.

Burnish With Colored Pencil
Do you want the background leaves to recede more? Try burnishing them with Olive Green. Press down on your pencil, and blend the new color with the others. Burnishing will mix the Black with the greens and will mute all the colors.

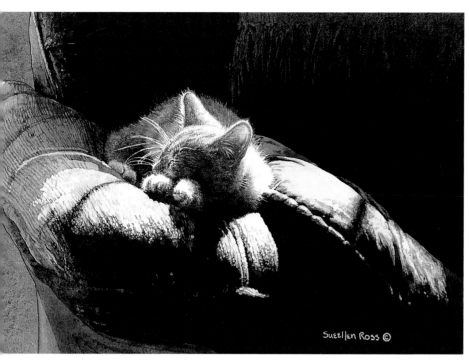

SUNSPOT
7" × 10⅜" (18cm × 26cm)

10 *Finish the Subject*
SUNSPOT

Starting from the top to avoid smearing, go over the kitten's lightest highlights with White pencil to brighten them. Get rid of harsh edges in your midtone shadows by softening them with Light Umber pencil. Do the same in your darkest shadow areas with Sepia and Black pencils.

Finish the details, like drawing in delicate whiskers and fur.

Make the inner ear the brightest spot in the painting by sharpening up the edges with Tuscan Red pencil, then applying lighter and lighter reds with tiny touches of Crimson Red and Orange pencils. Leave the top of the ear pale so it looks translucent.

Burnish light areas with warmth; try Cream or Yellow Ochre pencils over the White and its shadows.

Edge around the ears and the top of the head with Orange to make the kitten glow.

Last, polish the pencil surface to prevent "bloom," dust off any lingering colored-pencil dust, and spray with fixative.

10 *Finish Flower Faces*
DAISY FACES

Before you add the final touches to the foreground with colored pencil, make sure that everything makes sense. Which leaves and stems belong in the foreground? Where does each flower come from?

Do you want any of the foreground leaves to recede a bit? If so, burnish them with Olive Green pencil to diminish their intensity.

To make the highlights on the flowers pop out, add White pencil to the petals and hot yellows like Goldenrod and Orange pencils to the flower's centers. Warm up your gray shadows by burnishing them with Cream pencil in the lighter areas and Yellow Ochre pencil in the darker shadows, especially near the centers of the flowers.

Polish, dust and spray. You're done!

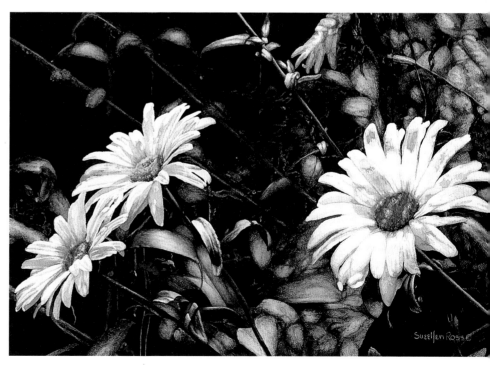

DAISY FACES
7¼" × 10¾" (18cm × 27cm)

MORE COLORED-PENCIL TECHNIQUES

PENCIL OVER INK

Iridescence

Think of the head of a peacock, a mallard or a wood duck. You can achieve that iridescent look with colored pencil drawn directly on top of India ink. By juxtaposing hot and cold colors that bounce off each other, you create a shimmery look, and the effect is enhanced by a pure black background.

Water

Slate Grey pencil over India ink spells *water*. Try painting some scrap paper with ink and drawing Slate Grey on top of it. Add other colors. Try reflections, squiggles and the concentric circles made by rain drops in a puddle. Try glazing over an entire area of ink with Slate Grey, heavily at first, then gradually lighter and lighter.

Vegetation

Drawing vegetation on top of India ink creates a muted, background look. Sepia, Olive Green, Burnt Ochre and rich, dark greens look particularly beautiful when used this way. Draw leaves, trees and stems just as you would on white paper, but remember that if they are drawn on India ink, they'll be the darkest value in your painting.

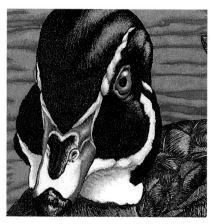

Iridescence
Draw Spring Green pencil on top of the head and on the side and cheek where the light hits.

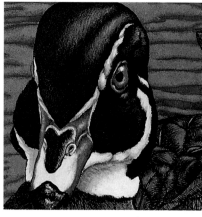

Bounce Colors
Blend the edges of Spring Green with Peacock Green pencil. Notice how the hot Spring Green and cool, dark Peacock Green bounce off each other, especially when applied over India ink.

For added iridescence, add a touch of Magenta pencil near, but not touching, the green areas.

Add iridescence to the back feathers too, using combinations of Magenta with Slate Grey pencil and Magenta with Yellow Ochre pencil.

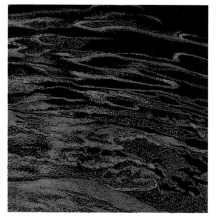

Reflections
The thicker you apply colored pencil over ink, the brighter it looks. Here, Slate Grey is applied lightly to make the darker reflections on the water, then highlights are added with heavier applications of the same color.

Vegetation
Here is a complete pencil drawing, using White, Spring Green, Olive Green, Sepia and Burnt Ochre pencils. Because it is drawn over India ink, it is very muted in color and intensity.

PENCIL OVER WATERCOLOR

Iridescence

Certain colors, when placed next to each other, bounce and create the illusion of iridescence. We've noted that the effect of applying these colors with colored pencil on top of India ink can be electrifying. But even on top of paler colors, the colors shimmer.

Try using Lilac and Orange pencils next to each other. Also try Magenta with Yellow Ochre, or Magenta with Slate Grey on top of brown feathers. The effect will be less intense than over the black, but can be very beautiful.

Water

When placed on top of dark blues, browns, and greens, Slate Grey (or any light blue or gray) looks like water's reflective surface. Highlight the cool blues with White pencil to add more sparkle.

Paint the back feathers of a bittern.

Bouncing Colors
A bittern's brown back feathers look dull until the light hits them. Then they light up like a rainbow. Use Lilac and Orange pencils—one very cool and one very hot—to bounce against each other and create the illusion of iridescence.

Soften and blend the harsh edges of ink and watercolor with Sepia, Light Umber and Red Ochre pencils. Highlight with White pencil.

Water's Reflections
Mix a bit of Burnt Sienna and Sap Green watercolor to make an olive landmass. Then use any cool blue pencil to highlight the surface of the water. Here I've used Slate Grey pencil, mixed with some White, to produce little inlets in the foreground.

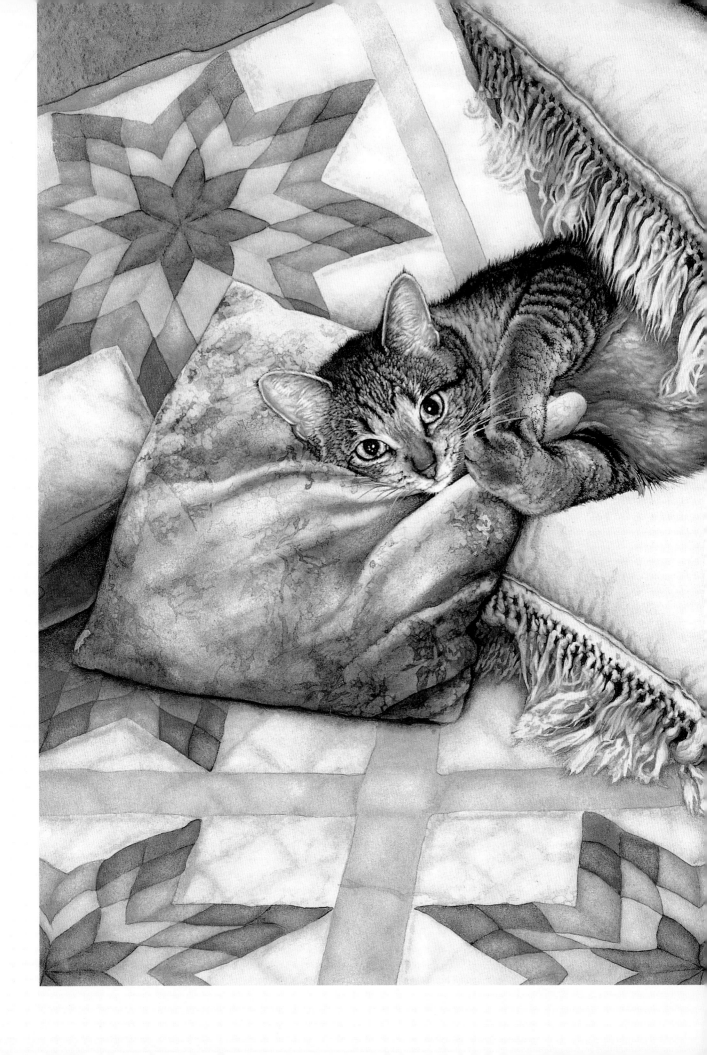

SueEllenRoss©

COZY INTERIORS

Step by Step

Interior decorating in real life is often frustrating. Dreams and visions are compromised by practical considerations—like money and availability of materials. But when you design a painting of an interior space, you can be as free and extravagant as you like. Now your efforts are only compromised by your ability to paint them!

The combined use of ink, watercolor and colored pencil is particularly successful for painting interiors. Ink keeps things contrasty and punchy. Watercolor, especially when applied in multiple glazes, gives you any effect you want, from rich, dark tapestry to pale, washed-out antique lace, from marble to mahogany. And, colored pencil adds surface textures like nothing else can. This chapter focuses on applying the mixed-media techniques to paintings that include fabrics, rugs, furniture, fireplaces, wood and other surfaces.

STARGAZER
12½″ × 14″ (32cm × 36cm)

Fabric
Collecting and arranging elements for paintings of "cozy interiors" is one of my favorite occupations. Holly, the "star" in *Stargazer*, belongs to friends in Florida. Here she nestles in my own bed. The little pillow she holds was a favorite of my late mother. (I almost called the painting *Edie's Pillow*.)

To give fabrics a soft, used look (which my linens definitely have), paint a pale shadow wash of French Ultramarine mixed with Burnt Sienna. Then paint on your other colors. I apply a final glaze of shadow mix over the bright colors, making them bleed into each other a bit and diluting their intensity. If I want to bleach out an area further, I scrub it with an old watercolor brush, blotting up the wet paint with tissue.

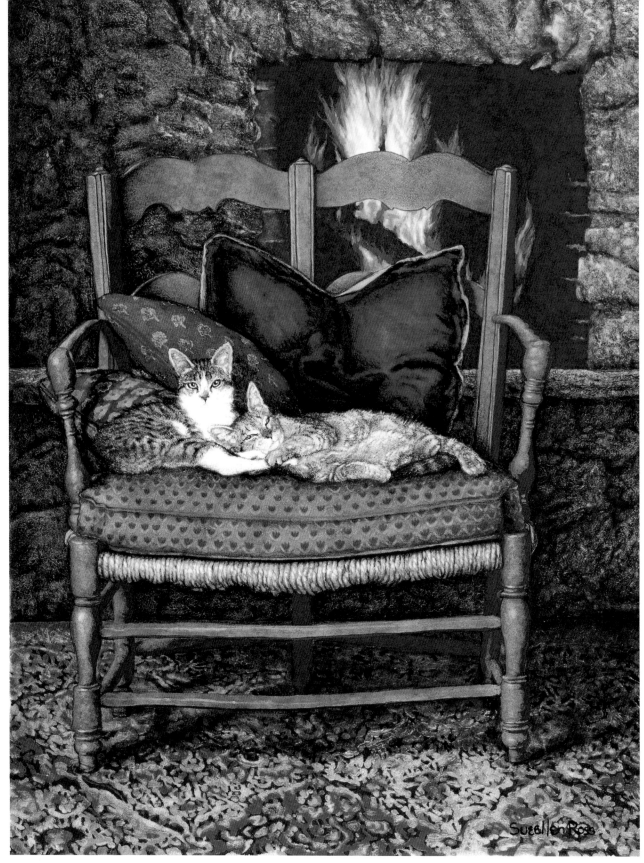

A Dream Spot

My friends asked me to paint their cats, Holly and Ivy. I started thinking about the cats' names. Before I knew it, I was dreaming of winter.

I got the idea for the fireplace from a mail order catalog. The chair resembles one I found in an interior design magazine. The big pillows and the rug are mine; the other pillows are my versions of designer fabrics. The chair cushion is covered with the fabric of Holly and Ivy's owners' couch. (Note: If you directly copy an image from a catalog, magazine or other copyrighted publication and do not get permission to do so from the artist or photographer, you are breaking copyright laws.)

HOLLY AND IVY
10¼″ × 8½″
(26cm × 22cm)

ORIENTAL RUGS

COLORS

WATERCOLOR
Aureolin
Bright Red
Burnt Sienna
French Ultramarine
Hooker's Green
Indigo
Permanent Alizarin
 Crimson
Quinacridone Gold
Sepia

COLORED PENCIL
none

1 *Watercolor Step*
Bottom Shadow Color

Once you've done a complete graphite drawing of your rugs, and laid in your darkest value with ink, it's time to add color. Paint a graded wash of a pale French Ultramarine/Burnt Sienna mix on your rugs and on the fringe to tone down their intensity, making it darker at the top as the rugs recede. Use a the same mixture to make shadows in the fringe.

2 *Watercolor Step*
Background Reds

Mix Alizarin Crimson with a touch of Sepia and a hot orange-red (I've used Winsor & Newton's Bright Red). Apply it full strength on the dark rug, and watered down a couple of shades for the two reds in the light one.

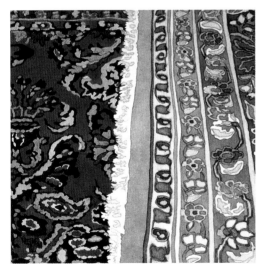

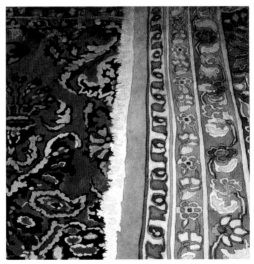

3 *Watercolor Step*
Add Bright Colors

Fill in all the bright colors, full strength on the left and diluted on the right.

For both rugs, try Quinacridone Gold, Indigo, Indigo mixed with Hooker's Green (dark blue-green) and Hooker's Green mixed with Aureolin (bright aqua).

4 *Watercolor Step*
Final Glazes

Erase all visible graphite pencil now.

Mellow all the colors, and make the rugs and fringe look older with a very pale glaze of Quinacridone Gold. Add a deeper shadow of French Ultramarine mixed with Burnt Sienna at the top. This will make the rugs recede more naturally. Your rugs are now complete; there is no colored-pencil step.

WOOD/CANING/UPHOLSTERY

1 Drawing/Inking Step
Complete Drawing, Lay Shadows

Do a complete graphite drawing of the chair, the caning and even the tulip pattern on the cushion.

Use India ink for the deep shadows between the chair and the cushion and in the caning.

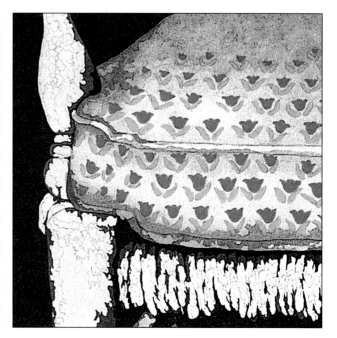

2 Watercolor Step
Add More Shadows and Fabric Pattern

Put in the next-lighter shadow on the wood and caning with Sepia watercolor. Wash a mix of French Ultramarine and Burnt Sienna on the cushion, darkening it a bit toward the back and around the seams.

Using Vermillion and Canary Yellow pencils, fill in the tulips on the cushion. Don't bother to run the pattern all the way back, where it will be obliterated by dark shadow.

3 Watercolor Step
Next-Lighter Colors

Paint rich Burnt Umber as the next-lighter color on the wood. Add Raw Umber as the next color on the caning.

Mix Hooker's Green with Sepia watercolor and paint a medium-dark wash over all of the cushion, painting right over the tulip design.

COLORS

WATERCOLOR
Burnt Sienna
Burnt Umber
French Ultramarine
Hooker's Green
Raw Umber
Sepia

COLORED PENCIL
Black
Canary Yellow
Goldenrod
Light Umber
Olive Green
Sepia
Vermillion
White

4 Watercolor Step
Finish Wood and Caning

Going from dark to light by adding more water to your paint each time, paint in three progressively lighter strengths of Burnt Umber on the wood, and three progressively lighter strengths of Raw Umber on the caning. Leave a highlight of white paper on each wrap of the caning.

5 Colored-Pencil Step
Soften and Blend Edges

Soften the transitions between watercolor areas with the following pencils: For the wood, use Sepia in the dark areas and Light Umber in the lighter ones. For the caning, use Sepia and Light Umber, warming the color with Goldenrod and highlighting each section with White. For the cushion, shade the darkest areas with Black, blend the black edges with Olive Green, and highlight the piping with White.

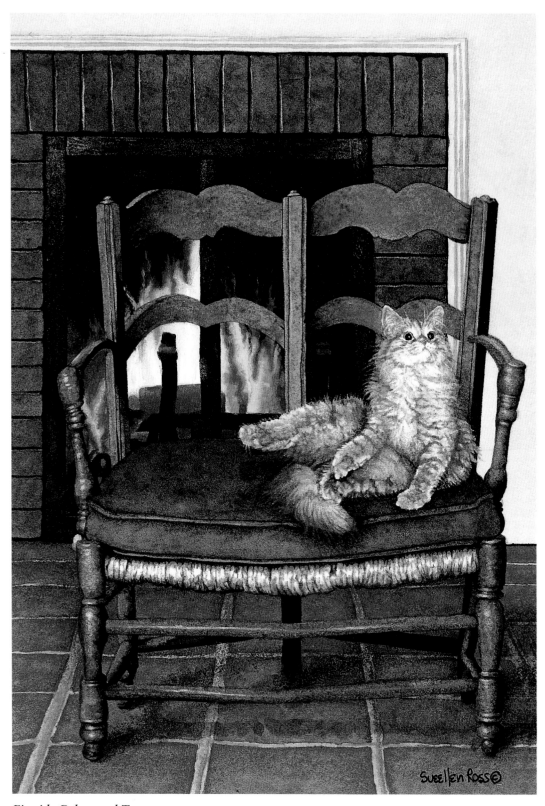

MUNCHKIN
7" × 5"
(18cm × 13cm)

Fireside Colors and Textures

To get the soft yellow of the wall and the mellow terra cotta of the floor tiles, paint a wash of shadow color underneath your main colors. (The wall is Quinacridone Gold and the floor is a combination of Burnt Sienna and New Gamboge.) Put even more shadow color on top where it's needed. I've put extra shadow under the chair this way, darkening it further with Black pencil.

The wrought iron fireplace screen is India ink, highlighted with a bit of French Grey 10% pencil.

FIREPLACE

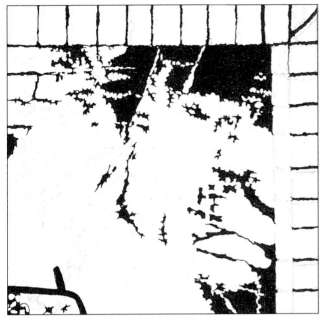

1 Drawing/Inking Step
Complete Drawing, Inking

Draw in the tiles, walls, and-irons and flickering flames of the fire. Using India ink fill in the shadows between tiles, the fireplace corners away from the flames, and the andiron.

COLORS

WATERCOLOR
Aureolin
Bright Red
Burnt Sienna
French Ultramarine
Hooker's Green
Permanent Alizarin
 Crimson
Sepia

COLORED PENCIL
Black
Burnt Ochre
Canary Yellow
Crimson Red
Orange
Sepia
Tuscan Red
White

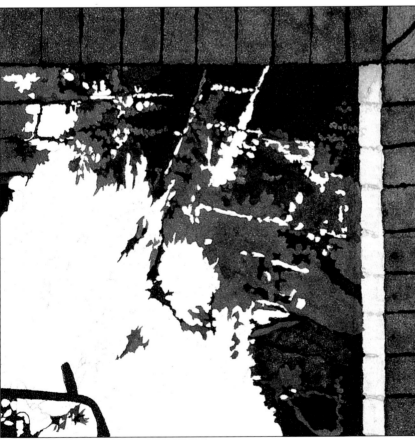

2 Watercolor Step
Tiles and Dark Reds

Paint the tiles, one by one, with a mix of Hooker's Green and Sepia. Paint the inside of the tiles with a pale mix of French Ultramarine and Burnt Sienna, with a darker shadow at the top.

Mix up a batch of dark fire red with Sepia, Permanent Alizarin Crimson and Winsor & Newton's Bright Red. Paint in the darkest red, then add extra Bright Red for your next-lighter color.

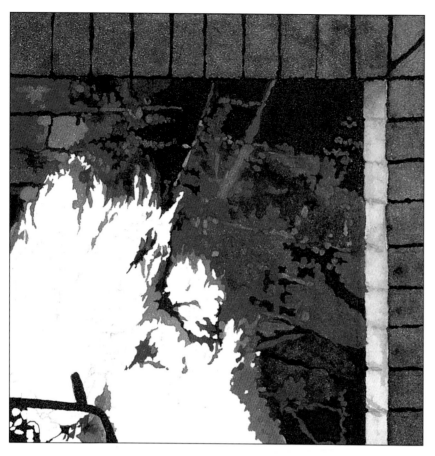

3 *Watercolor Step*
Add Lighter Reds

For the next lighter red, add more Bright Red to the existing mixture. For an even lighter red, add even more Bright Red, and then use pure Bright Red for an even lighter red.

Glaze the inside of the tiles using a little Bright Red to reflect the fire.

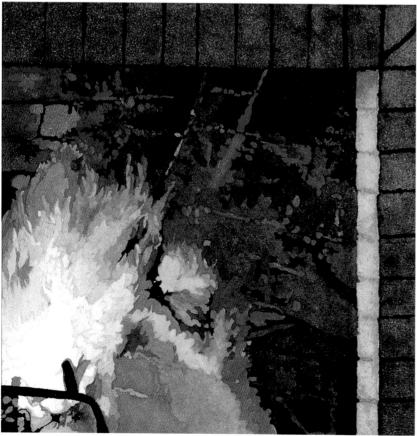

4 *Watercolor Step*
Paint the Flames

Add some Aureolin to the Bright Red and paint this mix onto the flames. Next, add much more Aureolin. Add a third coat of Aureolin with just a touch of Bright Red. Finally, paint in straight Aureolin.

Leave some white hot paper showing in the middle of the flames, and glaze a bit of Aureolin over the tiles to heat them up even more.

Erase all visible graphite drawing pencil marks when your watercolor is complete.

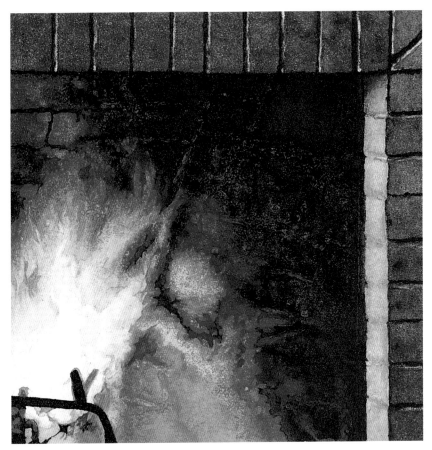

5 Colored-Pencil Step
Soften Edges

Use your Black, Tuscan Red, Crimson Red, Orange, and Canary Yellow pencils to gradually blend each edge in your fire into the next lighter color, but leave all the white paper in the center of your fire free of pencil color.

Highlight the edges of the green tiles with White pencil. Add a touch of Burnt Ochre pencil to them to create the fire's reflected glow. Darken the shadow in the top inside corner of the tiles with Sepia and Crimson Red pencils, and add a little Canary Yellow pencil for extra glow.

If you feel the need to darken and blend the colors in the fireplace further, glaze with Black pencil around the edges and with Crimson Red toward the middle.

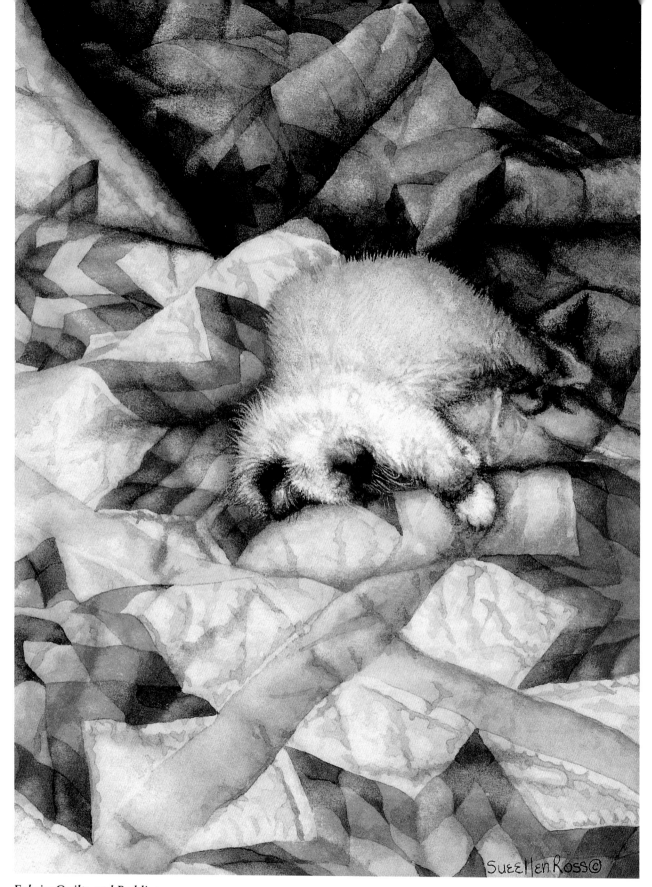

SueEllenRoss©

Fabric: Quilts and Bedding

A shadowy mixture of French Ultramarine and Burnt Sienna creates the roundness of the folds and the indentations made by the stitching. It also casts the quilt in deep shadow toward the back.

 First, put in the shadows cast by the folds and seams. (The very darkest shadows are India ink.) Once most of the texture and shading are in, add the bright colors of the quilt pattern. A shadow glaze over the top will soften these colors. Scrubbing the areas that are hit by light will add more highlights and softness.

TOFU NAPPING
7" × 5"
(18cm × 13cm)

QUILT

1 *Drawing/Inking Step*
Complete Drawing, Lay Shadows

Drawing quilts is as tricky as making them. Figure out the quilt pattern and how it is affected by the folds and lumps of a rumpled bed. Then, take a closer look. Do you see all the little shadows cast by the crisscrossing seams of the quilt? If you can indicate some of these at strategic spots, you will achieve that "quilted" look. Draw some of them in with a pencil to create a map.

Pick the very darkest shadow areas in the quilt and fill them in with India ink.

2 *Watercolor Step*
Build Shadows

Wash a pale mixture of French Ultramarine and Burnt Sienna over the whole quilt. This will soften the colors and give them an "antique" look. Then fill in the next-lighter shadow areas with a stronger mix of the same colors.

COLORS

WATERCOLOR
Burnt Sienna
French Ultramarine
Hooker's Green
Opera
Payne's Grey
Permanent Alizarin
 Crimson
Quinacridone Gold
Sepia

COLORED PENCIL
Black
Light Umber
Sepia
Yellow Ochre

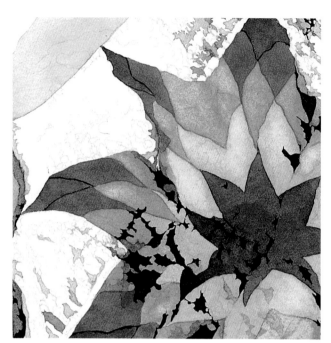

3 *Watercolor Step*
Add Bright Colors

Put in all the bright colors now, while you can still see your pencil drawing well enough to tell where things go. Use Payne's Grey for the pale blue and Hooker's Green mixed with Sepia for the dark green. Add red, using Permanent Alizarin Crimson mixed with a bit of Quinacridone Gold, and then add pink using a pale Opera/Quinacridone Gold mix.

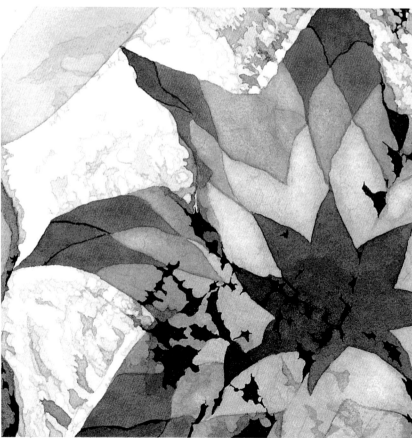

4 *Watercolor Step*
Add Texture

Using your previous mixture of French Ultramarine and Burnt Sienna, continue to fill in the small areas of shadow created by the stitched seams. This will give the surface of the quilt a raised, puffy look.

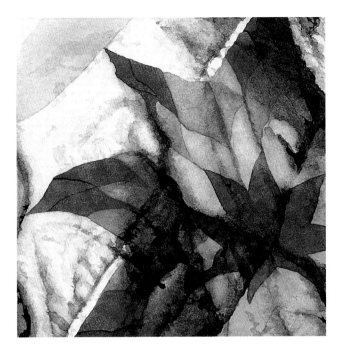

5 *Watercolor Step*
Create Dimension

Paint a pale glaze of shadow color over the whole quilt. This will cause the colors to fade and bleed and produce an "antique" look. If certain colors bleed too much (like the red), blot up the excess with a tissue.

Now with the quilt pattern in place, you can tell where your dark shadows go. Mix French Ultramarine with enough Burnt Sienna to produce a warm cast. Paint in strong, dark shadows and, if they need it, soften their edges with a clean, wet brush. To achieve a three-dimensional look, the shadows should be almost as dark as the ink.

6 *Watercolor/Colored-Pencil Step*
Final Touches

For a distressed, antique, textured look, try scrubbing your lightest areas with a clean, wet, old brush and blot up the excess paint and water with tissue. Notice the dark green areas; I've scrubbed out all the highlights.

Soften your ink edges with pencil: Use Black, Sepia or Light Umber, depending on how light the adjacent area is. Soften and warm lighter shadows with Yellow Ochre pencil. Use it only on the shadows. Keep your white areas clean.

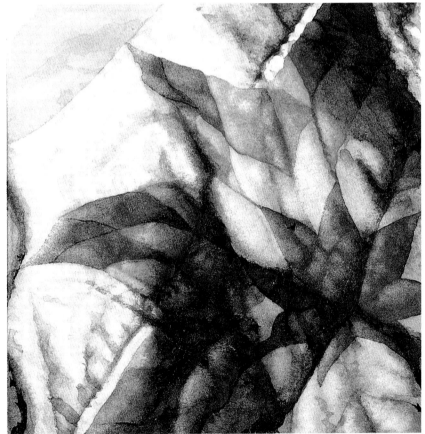

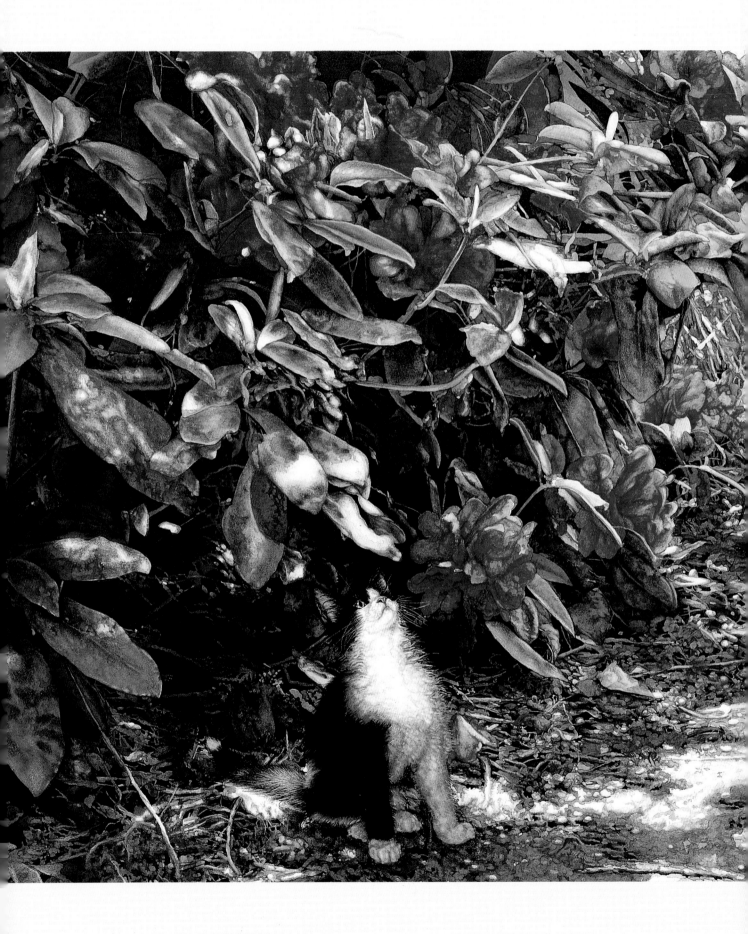

FLOWERS AND GARDENS
Step by Step

Flowers, fruit, trees, bushes, grasses, stone, dirt, bark—anything found in the garden (or in the natural world, for that matter) can be made to look vibrant and real using a combination of ink, watercolor and colored pencil. We can only cover a few garden elements in this chapter, but the principles of layering one medium on top of another in a specific order at a specific time apply to all outdoor subjects.

Notice how often garden subjects start with a tonal painting (or grisaille) of shadow existing underneath the final colors.

Notice how often we work in reverse, starting with the dark shadows between blades of grass and leaves and filling in the lighter, brighter colors of the vegetation after all the shadows are done.

Notice how we build from dark to light, from background to foreground, from dull to bright.

Notice that the brightest areas, like flowers in the sun, get simple, direct applications of watercolor; they may or may not need further brightening with colored pencil.

And notice that, in general, garden subjects do not rely as heavily on the final colored-pencil step as do animals and birds.

BIRD ENTHUSIAST
17" × 22" (43cm × 56cm)

Painting Light and Texture
Our house is hidden in a greenbelt. The only access to it is a winding gravel driveway, guarded at the top by an elderly rhododendron and, in this painting, by a kitten.

A tree canopy shades the driveway as you approach the house (and the front of the painting). The background is in full sun, with hot yellows and pale colors. By the time you get to the kitten, all that remains of the sun is a few splashes of light in the leafy gloom.

The other main theme in the painting is texture—gravel and dirt, heavy-petaled rhodies, shiny dark leaves, fur and unkempt grass.

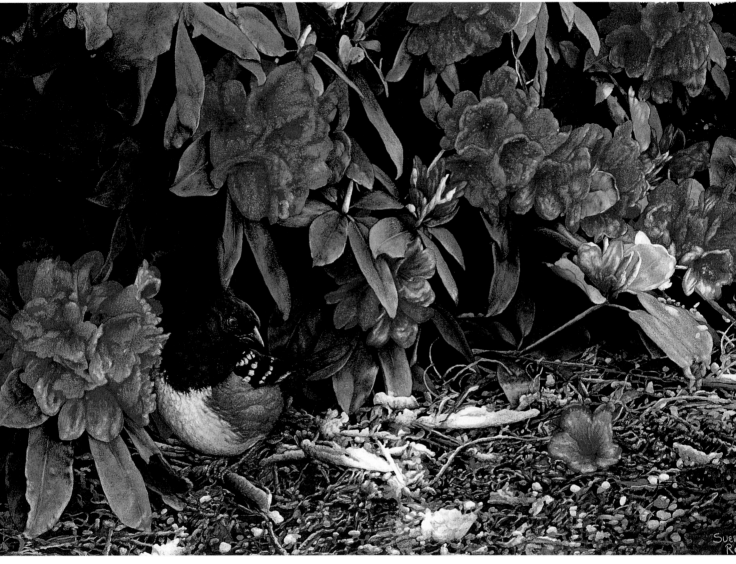

Now You See Him—Now You Don't
Only his jerky movements betray the presence of this beautifully camouflaged towhee. He is especially hard to see on the gravel driveway, with its sticks and stones and dappled light.

India ink surrounds each island of color, is threaded all throughout the gravel and forms the top half of the towhee.

ROSS GARDEN #3—RUFOUS-SIDED TOWHEE
10½″ × 16½″ (27cm × 42cm)

RHODODENDRONS

1 Drawing/Inking Step
Complete Drawing, Lay Shadows

Shadows fall across the driveway and lawn; the rhodies lie almost completely in shadow. Decide where you want the shadows to go in the drawing step.

The upper left is in deep shadow; use ink there. The rhody leaves also get ink. Use ink only in the deepest shadows, away from the light. Do not use ink on the flowers or for the shadows in the lawn or driveway; these will be your midtone values.

2 Watercolor Step
Paint Darks

Mix up dark shadow color with French Ultramarine and Burnt Sienna. Use enough blue to cool the mixture. Paint the darkest shadows (after ink) in the lawn and driveway.

Select and paint your very darkest green leaf areas with a dark mix of Hooker's Green and Sepia.

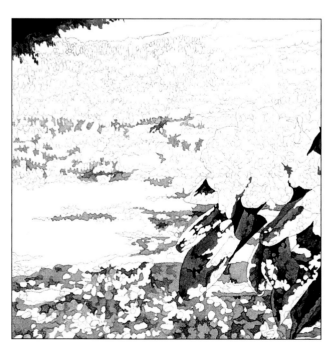

3 Watercolor Step
Add More Shadows

Paint in two more shades of shadow color, going warmer and lighter. (Add a bit more Burnt Sienna and water to your mix each time.) The shadows at the bottom are quite dark.

Paint the next-lighter green of the leaves (Hooker's Green and Sepia with a little Permanent Sap Green). Then paint the darkest red of the flower, using a combination of Alizarin Crimson, Winsor Red and Charcoal Grey.

COLORS

WATERCOLOR
Aureolin
Burnt Sienna
Charcoal Grey
French Ultramarine
Hooker's Green
Opera
Permanent Alizarin
 Crimson
Permanent Sap
 Green
Sepia
Winsor Red

COLORED PENCIL
Limepeel
Olive Green
Pure Green
Tuscan Red
White

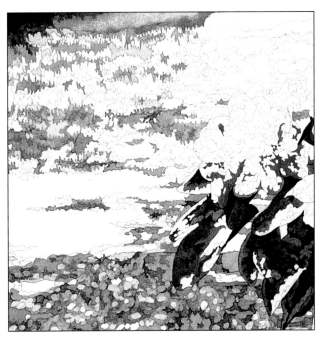

4 *Watercolor Step*
Go Warmer and Lighter

Add two more shadow values, using more Burnt Sienna and water each time.

Add more Sap Green and a touch of Aureolin to the leaf green and paint in the next-lighter green. Add more Winsor Red and some Opera to your dark red mix, and paint your next-lighter red in the flowers.

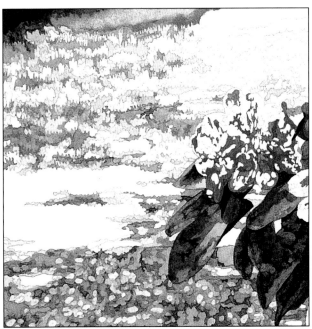

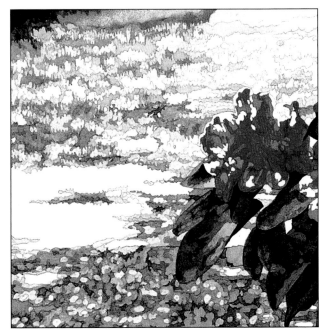

5 *Watercolor Step*
Go Lighter Still

Keep filling in shadow areas with warmer, lighter color.

For the next-lighter leaf green, try straight Permanent Sap Green. For the leaf highlights, add a little Aureolin to the Sap Green. For the next-lighter pink, add more Opera to your present flower color.

6 *Watercolor Step*
Finish Shadows, Work on Flowers

Your two final applications of shadow color should be very warm and very pale.

Also, add more warmth to the flowers by adding a little Aureolin to your red mix.

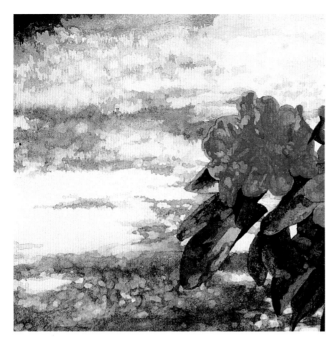

7 *Watercolor Step*
Soften Shadows, Finish Flowers

Erase the graphite from your background. Use an old watercolor brush to gently scrub the edges of the shadow areas to soften them. If needed, punch up the darkest shadow areas with a cool, dark mix of French Ultramarine and Burnt Sienna.

Add straight Opera as your final flower color.

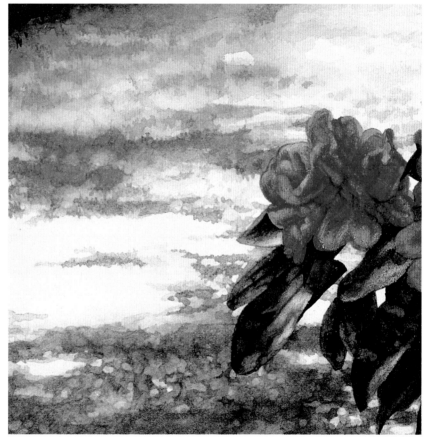

8 *Watercolor/Colored-Pencil Step*
Final Touches

Glaze straight Hooker's Green over the darkest lawn areas (this will look blue-green). On the sunny lawn areas and right over the Hooker's Green, glaze Aureolin with a bit of Permanent Sap Green added to it.

Shadow the rhodies in areas away from the light by glazing with a cool shadow mix. (Add extra French Ultramarine to make it very blue.)

Highlight the rhody leaves with White pencil, blending the edges with Limepeel pencil. Soften the ink edges with Olive Green pencil. Darken (and deepen) the centers of the flowers with just a touch of Tuscan Red pencil. Highlight the outer petals toward the light with White.

GRAVEL PATH AND BLOSSOM

COLORS

WATERCOLOR
Aureolin
Burnt Sienna
Charcoal Grey
French Ultramarine
Hooker's Green
Opera
Permanent Alizarin
 Crimson
Permanent Sap Green
Quinacridone Gold
Sepia
Warm Grey Liquid Acrylic
 Color
Winsor Red

COLORED PENCIL
Crimson Red
White

1 Drawing/Inking Step
Complete Drawing, Lay Shadows

You may choose never to get this detailed again. (I can't blame you.) But this exercise teaches you how to work in reverse. Once you know how to start with your darks, you can use this technique for anything you want to paint.

Carefully draw sticks, stones, some leaves and one rhododendron blossom. Decide where the light is coming from, and ink in shadows behind each object.

2 Watercolor Step
Paint Darks

Start building a grisaille of shadow color with a mix of French Ultramarine and Burnt Sienna. Use more blue for your darkest areas.

Pull out your darkest colors and paint them in. Use Sepia for the wood and Hooker's Green mixed with Sepia for the vegetation.

3 Watercolor Step
Build a Grisaille, Start the Flower

For the next-lighter earth color, add water and a bit of Burnt Sienna to your shadow mix. Add this color to your dark areas throughout.

Now add the bright Aureolin center of the fallen rhody blossom. Then paint in the darkest red area with a mixture of Alizarin Crimson, Winsor Red, and a touch of Charcoal Grey to darken it.

4 Watercolor Step
Lighten the Shades

Make your next-lighter shadow color a little paler and even warmer than the previous, to fill in the little midtone drift areas.

For the next-lighter green, add Permanent Sap Green to your dark green mix. Add Opera to your dark red mix for your next-lighter red.

5 *Watercolor Step*
Work on Dirt, Leaves and Flower

Cool the next-lighter shadow color by adding extra French Ultramarine mixed with water. Use this color extensively, filling in all dirt areas.

Paint midtone greens on the leaves in two stages. Start with straight Permanent Sap Green, then add water and Aureolin for a lighter, warmer color. Add more Opera and water to your red mixture, and paint the next-lighter red.

6 *Watercolor Step*
Finish Leaves and Flower

Cover most of the pebbles, sticks and leaves with Warm Grey acrylic, adding some water to make it a light gray. Leave a few white spots here and there as highlights.

Paint a few of your lightest greens with pale Hooker's Green (these will be very blue) and the rest with a mix of Aureolin and a bit of Permanent Sap Green (these will be very yellow). Add even more Opera to your red mix to finish painting the dark areas of the flower.

7 Watercolor Step
Create Dimension

Darken the shadows on the ground with your original, cool blue shadow mix. Don't cover up the sticks and stones.

Paint over the remaining white stones with very pale Quinacridone Gold. Fill in the final flower color using straight Opera with water added.

8 Watercolor/Colored-Pencil Step
Final Touches

Erase any visible graphite pencil.

Soften the watercolor edges of the flower by scrubbing very gently with water and a soft brush. Anywhere the flower color is too bright, glaze it with blue shadow color.

Keep glazing dark, bluish shadow color on the driveway until you get it as dark as you like, but don't cover up the bright stones or leaves.

Highlight the leaves and the blossom with White pencil. Sharpen the dark flower center with Crimson Red pencil.

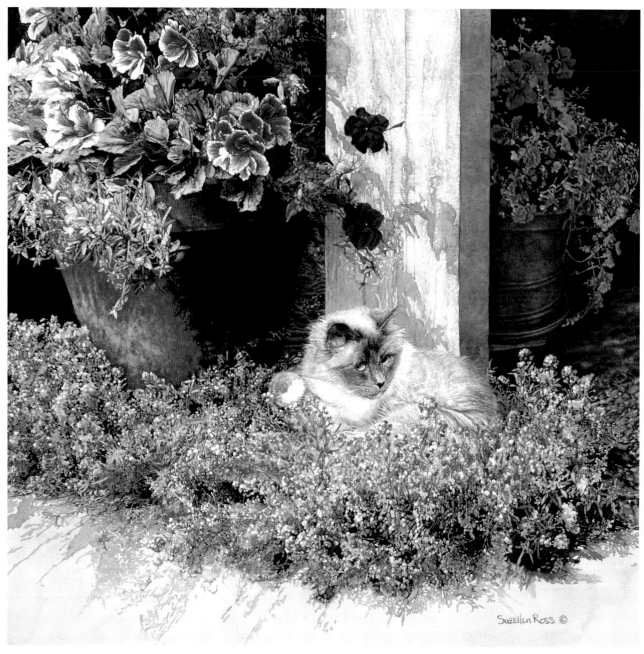

Sun Bath
Strong shadows splash onto a post. Others create lacy patterns under the alyssum and almost hide some of the flower pots from sight. Paint all of these shadows with mixtures of French Ultramarine and Burnt Sienna. A glaze of the same colors makes the pot at the right recede into the background.

A feeling of warmth is enhanced by the repeated use of reds, from pale violet to hot pink to fiery orange and finally to deep burgundy.

SWEET ALYSSUM
16½" × 16½" (42cm × 42cm)

SWEET ALYSSUM

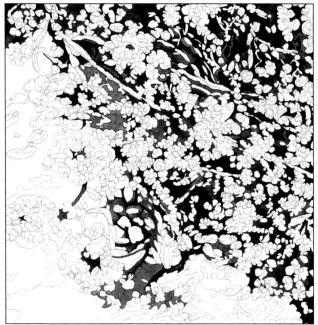

1 Drawing/Inking Step
Complete Drawing, Lay Shadows

As complex as it is, this drawing does not capture the structure of individual alyssum flowers. Each tiny flower has four petals and a green and yellow center. If you want to verify this, buy an alyssum plant and a magnifying glass.

Ink between the stems where the shadows are deepest. Use very little ink in the areas hit by the sun.

2 Watercolor Step
Paint Darks

Select your next-lighter shadows (after ink) between the flowers and on the concrete. Paint these with a dark, cool mixture of French Ultramarine and Burnt Sienna.

Now find the very darkest green leaves, and paint them with a dark Hooker's Green/Sepia mix.

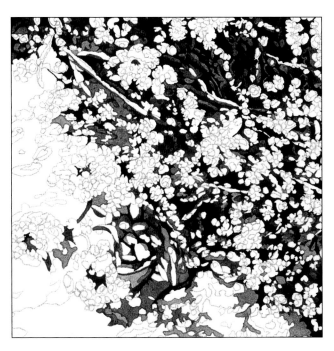

3 Watercolor Step
More Shadows and Greens

Add more Burnt Sienna and water to your shadow mix, and paint the next-lighter shadows throughout the flowers and on the concrete.

The next green is still dark, but warmer. Add Permanent Sap Green and a touch of Aureolin to your dark green, and paint this color in.

COLORS

WATERCOLOR
Aureolin
Burnt Sienna
French Ultramarine
Hooker's Green
Opera
Permanent Alizarin
 Crimson
Permanent Sap Green
Raw Sienna
Raw Umber
Sepia
Winsor Violet

COLORED PENCIL
Olive Green

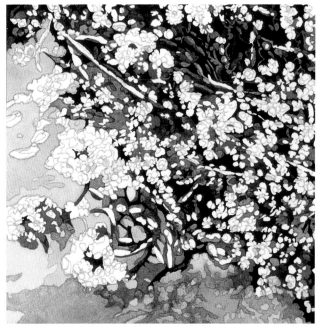

4 Watercolor Step
Finish Concrete, Start Flowers

Add more Burnt Sienna and water to your shadow mix. Paint this color throughout the flowers, and use it to cover the whole bottom section of the concrete.

Add a lot more water, and finish the rest of the concrete with this pale wash. Load your brush with paint, start at the edge of the darker shadow color and carefully paint around all the flowers. (I've left areas free of color for fallen petals, but you needn't bother doing so.)

Paint Aureolin centers into each flower, but don't worry about being too precise. Then select the darkest pink petals, and paint them in with a rich, dark mix of Permanent Alizarin Crimson and Opera.

5 Watercolor Step
Add Bright Greens and Pinks

For a bright yellow-green, mix some Aureolin into Permanent Sap Green and use it extensively throughout the leaves.

Add more Opera to your pink mixture and paint the next-lighter petal color.

6 Watercolor Step
Finish Leaves, Continue Flowers

The two final greens are pale Hooker's Green (bluish) and Aureolin with a touch of Permanent Sap Green (yellowish).

I now have a confession to make. I just couldn't see enough detail in my photos of alyssum, so I went out and purchased some of the real thing, which happened to be purple. I've added Winsor Violet (Winsor & Newton) to the palette here. Glaze directly over the existing darkest pinks for a glorious, complex color. Then use Winsor Violet straight on the next-lighter petals.

7 Watercolor Step
Finish Flowers

Each alyssum flower should have a few pure white petals. Paint the remaining petals with Winsor Violet warmed up with some Opera. These petals should be quite pale and will bounce off the cool, straight violet you just used.

Add dried petals and leaves for contrast, using Raw Umber or Raw Sienna watercolor.

8 Watercolor/Colored-Pencil Step
Final Touches

Erase any graphite pencil that shows on the concrete and white petals. Then, with your dark, cool shadow mix, deepen the "holes" in your flowers by glazing over and darkening some of the interior vegetation. Knock back the vegetation at the top left.

This painting needs no pencil, but if you want to soften any ink edges or link up broken bits of leaves in dark areas, blend these with Olive Green pencil.

GERANIUMS

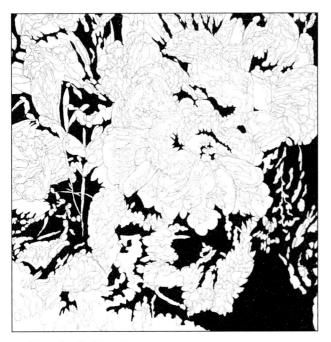

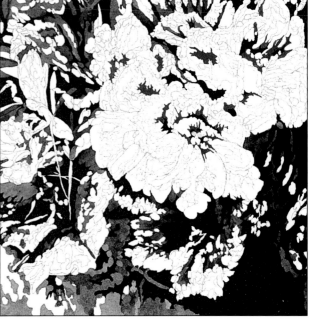

1 *Drawing/Inking Step*
Complete Drawing, Lay Shadows

Draw in the geraniums and pot. Ink only the very darkest part of the flower centers. Ink between the leaves and away from the strong light source that comes from the upper left; so apply more ink on the right side.

COLORS

WATERCOLOR
Aureolin
Burnt Sienna
Charcoal Grey
French Ultramarine
Hooker's Green
New Gamboge
Opera
Permanent Alizarin
 Crimson
Permanent Sap Green
Raw Sienna
Raw Umber
Sepia
Winsor Red

COLORED PENCIL
Burnt Ochre
Crimson Red
Dark Umber
Tuscan Red
Vermillion
White

2 *Watercolor Step*
Apply Darks

For the very darkest shadows, use Charcoal Grey watercolor. For your deepest greens, apply a dark mixture of Hooker's Green and Sepia.

Paint a second, warmer shadow on the terra cotta pot using French Ultramarine with lots of Burnt Sienna.

For the next-lighter green of the leaves, add Permanent Sap Green to your dark green color. Add spots of Aureolin in the center of the main flower, and put in the darkest red—a mixture of Alizarin Crimson, Winsor Red and Charcoal Grey.

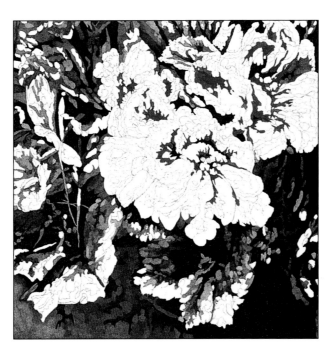

3 *Watercolor Step*
Glaze Warmer and Lighter

Glaze over the shadow color on the terra cotta pot with a Burnt Sienna and New Gamboge mix.

Add more Permanent Sap Green to the leaf green, and some Opera to your dark red.

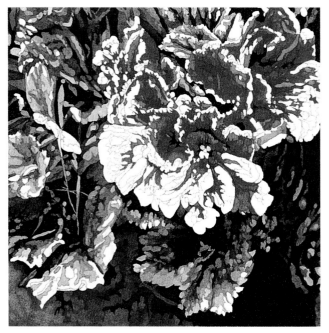

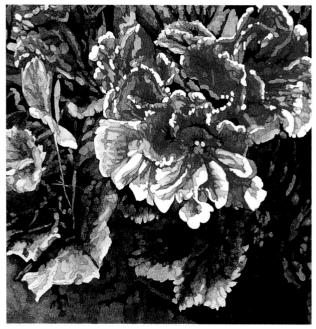

4 *Watercolor Step*
Build Up Greens and Reds

For a bright midgreen, mix Aureolin with Permanent Sap Green. Add more Aureolin to the bright leaf color for the next green, and even more for the following green.

Add more Opera to the dark red mixture to brighten and lighten it. To make the red even brighter, add a little Aureolin and more Opera for the following reds.

5 *Watercolor Step*
Bounce Colors

Add a pale wash of straight Aureolin to the leaf tips. Add just a touch of Raw Sienna or Raw Umber to the burned spots on the biggest leaves, and glaze the cool leaves at the top with a pale wash of Hooker's Green.

Move the color of the flowers toward bright orange by applying a mix of Aureolin and Opera in three stages, adding more water each time.

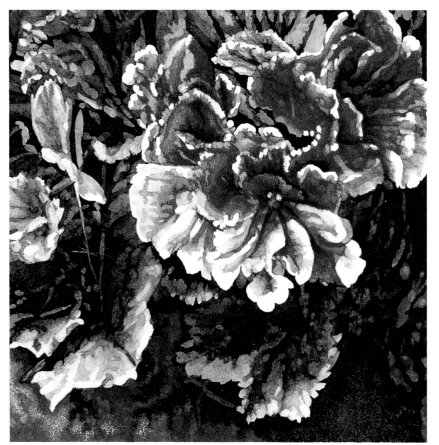

6 *Watercolor/Colored-Pencil Step*
Final Touches

Erase any graphite that still shows. Add more depth to the flowers and leaves by glazing them with dark, cool shadow color (French Ultramarine/Burnt Sienna mix). Use this glaze to make some areas recede and to darken the centers of the flowers.

Soften the dark ink edges on the pot with Dark Umber pencil. Use Burnt Ochre pencil on top of the ink at the lower right to round out the pot. Highlight the lightest areas of the pot with White pencil.

The flower centers can be darkened further with Tuscan Red pencil. Beef up wimpy dark reds with Crimson Red pencil; use Vermillion pencil for the lighter reds.

Highlight the leaf edges with White pencil.

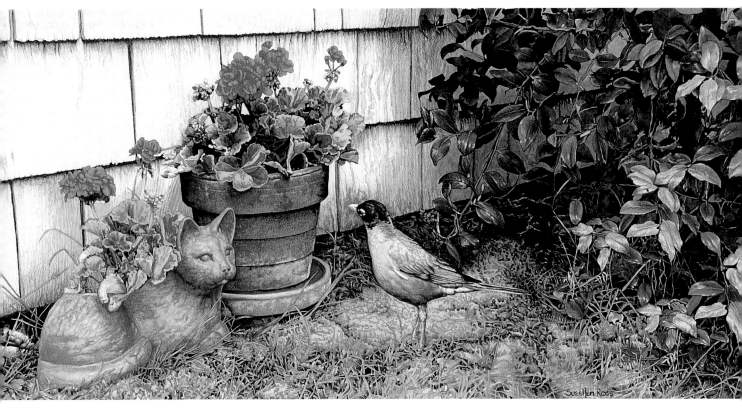

Basic Garden Elements
First use India ink for the darkest shadows between shingles. Then paint the shadows on the shingles to reveal their wood texture. On top of this grisaille, glaze a pale wash of Neutral Tint to give the shingles the look of weathered wood. Finally, smudge some Derwent Olive Green pencil along the bottom row to make them look mossy.

ROSS GARDEN #2—CAT ALERT
10½" × 22¾" (27cm × 58cm)

GRASS

1 Drawing/Inking Step
Complete Drawing, Lay Shadows

Most of the work of painting grasses is in the drawing and ink steps. You will be working in reverse, putting ink in the crevices between the blades of grass. Your graphite drawing will determine how detailed your final painting is, so draw every leaf and blade of grass now.

Determine where you want the darkest shadows and carefully fill them in with ink. Notice that the upper left corner is in a shadow cast by a bush and is very dark. The rest of the grass is in full sun and gets almost no ink.

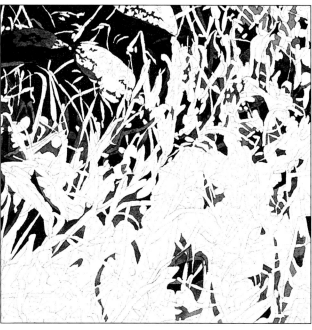

2 Watercolor Step
Paint in Darks

Paint your next-lighter values. Use Charcoal Grey for shadow areas, Sepia for dark wood, stems and dead leaves, and a mixture of Hooker's Green and Sepia for the darkest grass and leaves.

COLORS

WATERCOLOR
Aureolin
Burnt Sienna
Charcoal Grey
French Ultramarine
Hooker's Green
New Gamboge
Permanent Sap Green
Raw Umber
Sepia

COLORED PENCIL
Burnt Ochre
Light Umber
Limepeel
Olive Green
Sepia
Spring Green
White

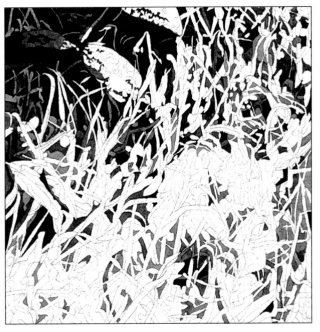

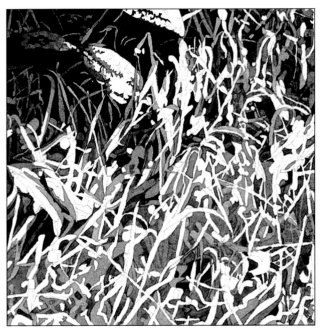

3 *Watercolor Step*
Paint Grass Shadows

Using a warm shadow color, like French Ultramarine mixed with Burnt Sienna, fill in the areas between the blades of grass to establish a pattern of dark shadows.

4 *Watercolor Step*
Add Greens and Reds

Fill in the basic grass and leaf color—Permanent Sap Green added to the Hooker's Green/Sepia mixture.

Next, add even more Sap Green to the mixture, and use this lighter green to fill in the areas throughout the grass and the leaves. Glaze this color over the shadows, too.

Pick out the stems, dried leaves and other russet areas, and paint them with a mixture of New Gamboge and Burnt Sienna.

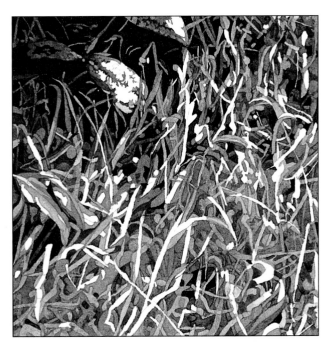

5 *Watercolor Step*
Paint Bright Greens

Your next green is a bright, pure Permanent Sap Green. Paint this on most of the grass blades and use it to fill in more darks on the leaves.

Add some Aureolin to the Sap Green for a bright, midyellow-green. This is your next-lighter green.

Wherever you see browns and yellows, add touches of Raw Umber and Aureolin.

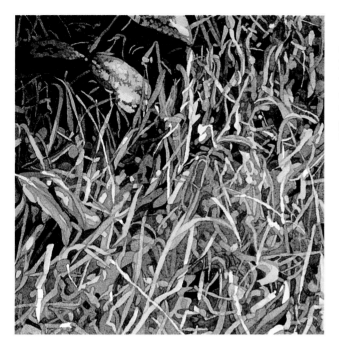

6 *Watercolor Step*
Paint Light Greens
Only the highlights on the grass and leaves remain white. Add a blue shade to some grass blades and leaves using a pale wash of straight Hooker's Green. Add yellow to the rest of the grass, using Aureolin mixed with a touch of Permanent Sap Green.

7 *Watercolor/Colored-Pencil Step*
Final Touches
Darken the top of the grass with a cool, dark glaze of a French Ultramarine and Burnt Sienna mix. Deepen any "holes" (pockets of shadow) throughout the painting, keeping the bottom of the painting lighter.

Highlight the leaves with White pencil, blending the white edges with Spring Green pencil. Soften the ink edges with Olive Green pencil.

Soften and blend the russet areas with Burnt Ochre pencil and the brown areas with Sepia and Light Umber pencils. Shade individual pieces of grass with Limepeel, Spring Green, and Olive Green pencils.

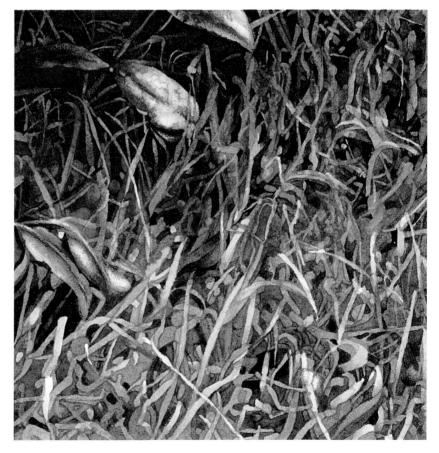

PETS
Step by Step

This chapter shows you techniques for creating portraits of a few specific cats and dogs. These techniques can be used for any animal in any situation or background; from budgies to boas, from goldfish to gerbils—any creature can be sensitively rendered using ink, water-color and colored pencil.

Think about attitude and expression and gesture, as well as anatomy and surface texture. Think about the effect the background has on your subject, both psycho-logically and physically. Is the animal comfortable and at home? What kind of lighting exists, and where is it coming from?

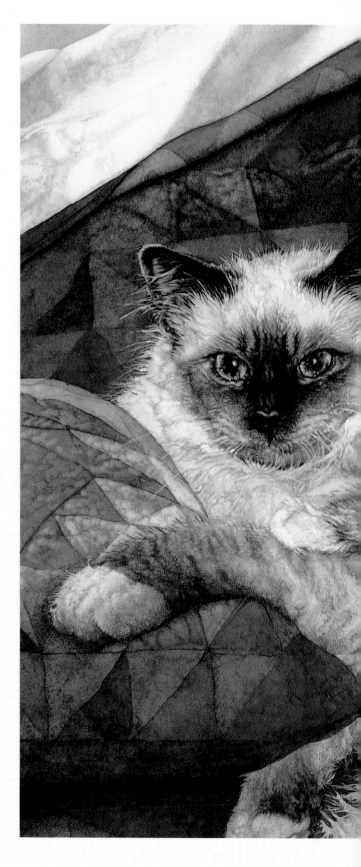

FAWN AND FORREST
10" × 18¾" (25cm × 48cm)

The Good Life
For this portrait of a friend's beautiful Birman cats, I chose a strong light source from the upper left corner that would highlight the cats' heads. And, I chose the soft, antiqued texture of the quilt to mirror the plushiness of the cats' fur. The folds and shadows disrupt the geometrical quilt pattern enough that it is not a distraction.

The main technique to use for this type of fur is Warm Grey acrylic with White pencil and Burnt Umber water-color. The cats' masks are mainly India ink and Sepia water-color. White, Cream, Light Umber, Sepia, and Yellow Ochre pencils do the majority of the work in the colored-pencil step. (I often paint cats and dogs from photographs given to me by their owners. If you work from other peo-ple's photos, make sure you have their permission—in writ-ing, if possible.)

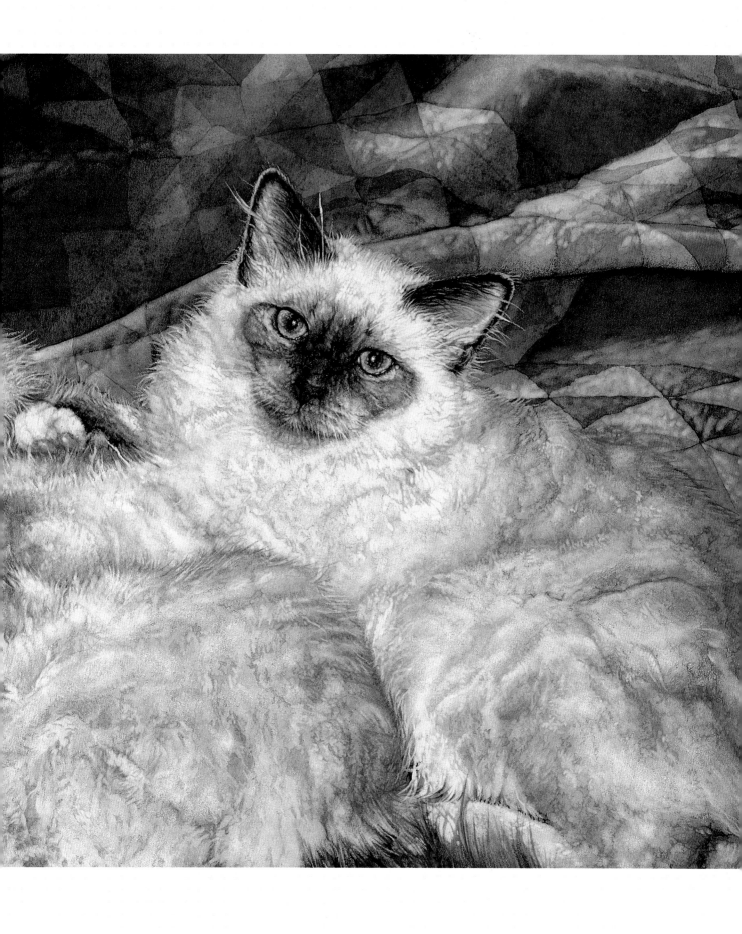

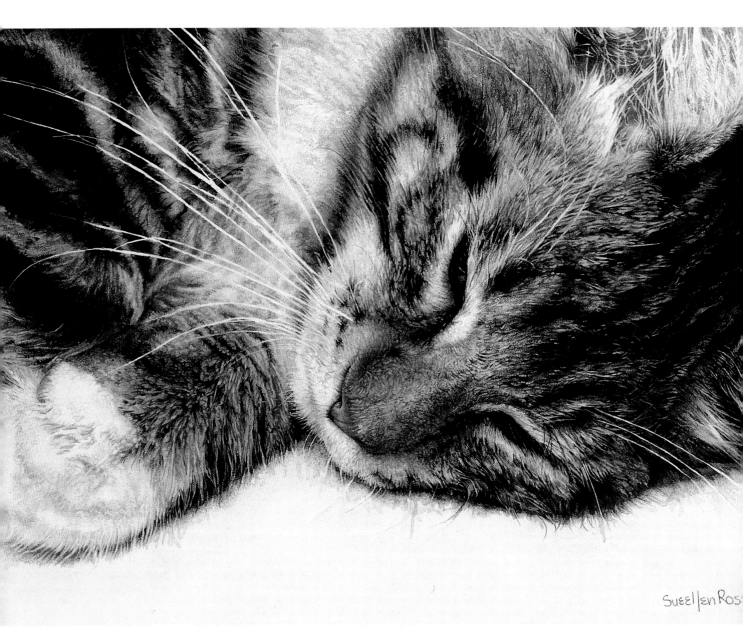

SueEllen Ros

Tabby Technique

Nothing is more universal, or, to my mind, more beautiful than a sleeping tabby, and no subject lends itself better to our mixed-media technique. Each stage can be used to its fullest. Much of the texture and detail of the fur can be developed in the inking stage. The whole range of grays, browns, reds and golds found on almost every tabby can be painted in the watercolor stage. The White pencil/ Warm Grey acrylic technique is perfect for the cat's white paw, ruff, muzzle and ears. And, colored pencil can fluff, soften and add glow to the fur at the end of the process.

MIDAS TOUCH
8⅛" × 11¼" (21cm × 29cm)

TABBY CAT

COLORS

WATERCOLOR
Aureolin
Burnt Sienna
Burnt Umber
Charcoal Grey
New Gamboge
Permanent Sap Green
Raw Umber
Rose Doré
Sepia
Warm Grey Liquid
　Acrylic Color

COLORED PENCIL
Burnt Ochre
Canary Yellow
Copper Beach
Cream
French Grey 10%
Goldenrod
Light Umber
Raw Umber
Sepia
White
Yellow Ochre

1 *Drawing/Inking Step*
Complete Drawing, Lay Ink

A lot of the work on striped and/or tipped fur can be done in the ink step. For black fur, fill in only the deepest black areas with ink. For black-tipped areas (between the ears and under the eyes), try stippling (making dots) with the ink.

The fur on a cat's face grows in several different directions, and it changes in texture from place to place. Be aware of this; it will affect your drawing and inking.

Draw black whiskers and hairs with your India ink pen, but leave light areas free of ink.

2 *Watercolor Step*
Paint Darks and Eyes

Tabbies have a lot of silky black fur. Charcoal Grey watercolor in these furry areas looks like deep black with a little reflected light. When you paint this color, be careful not to cover up any of the lighter-colored fur.

Paint the very darkest parts of the cat's eyes with Permanent Sap Green. Mix some Aureolin with the Sap Green and paint the next-lighter green.

3 *Watercolor Step*
Warm Darks, Pencil Resist

Start with a slightly lighter tone of Charcoal Grey and keep filling in the darkest parts of the fur.

Then switch to brown for the lighter fur. Use Sepia with some water added for the midtone browns, but don't paint over the Charcoal Grey with it.

Protect white areas from paint with White pencil. Retain the highlights in the eyes, the white cheeks, chin, eye rings, ears and whiskers by completely coating them with pencil.

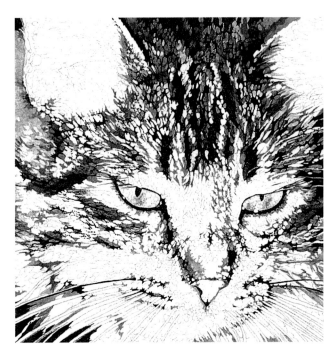

4 Watercolor Step
Start a Grisaille

Paint a first, very pale, layer of Warm Grey acrylic over the whole face, except for the eyes. Notice how the Charcoal Grey and Sepia blend and how the White pencil protects the lightest areas.

Lay a pale wash of Aureolin on the eyes. (You have already "saved" the white highlights with White pencil.)

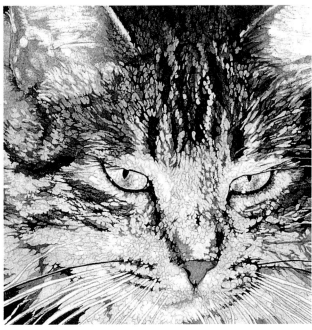

5 Watercolor Step
Build the Grisaille

Choose the next-lighter white areas. Protect them from further color by covering them with White pencil. Then glaze the whole face (except the eyes) again with the pale Warm Grey acrylic. Repeat the whole process once more.

Step back and determine what areas still need darkening. Darken these areas with diluted Sepia. Remember that the White pencil will protect the light areas, but avoid painting over the cool, Charcoal Grey fur.

Mix Rose Doré with Raw Umber and paint the pink ears, the nose and the mouth.

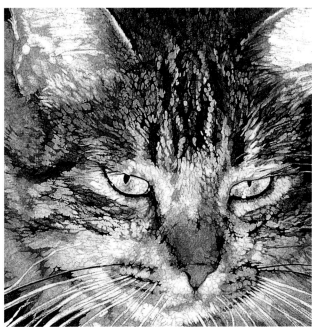

6 Watercolor Step
Warm Up the Colors

Select your final white areas, cover them with White pencil and glaze over the face one last time with Warm Grey Liquid Acrylic Color.

Mix a batch of midtone Burnt Umber and glaze over the whole face, except for the eyes, ears and nose. Add extra color around the edges, but keep the center of the face pale.

Mix Burnt Sienna with New Gamboge and accent the nose, cheeks and the inside corners of the eyes with this bright russet color.

7 Colored-Pencil Step
Draw the Fur

Erase all traces of White pencil and graphite pencil from the light areas. Erase the eyes, too. Notice that the highlights and whiskers emerge completely free of color when erased.

With White pencil, start drawing in the individual hairs in the ears, around the eyes and in the muzzle.

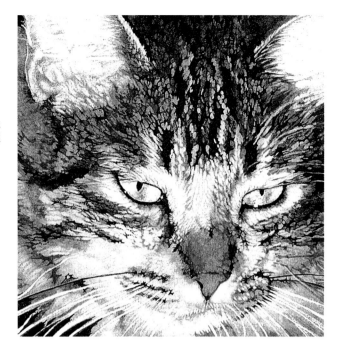

8 Colored-Pencil Step
Final Touches

Brighten the eyes with Canary Yellow and Goldenrod pencils. Shadow the ears with Copper Beach pencil and glaze over them with Cream pencil. Draw dark hair at the edge of the ears with Sepia pencil.

Soften the fur in front of the ears with White. Blend the roots of the hairs with Raw Umber pencil, and glaze over the area with Cream.

With a French Grey 10% pencil, add light hairs in darker areas for the tabby's salt-and-pepper look. Use French Grey 10% pencil to blend the base of the hairs into the darker fur with Sepia.

Add light hairs in the middle of the nose with Cream. Then blend them into the darker areas using Burnt Ochre pencil, and glaze over the whole nose with Yellow Ochre pencil.

Use Light Umber pencil to soften the black whisker spots on the cheeks.

With White pencil, clean up the white areas, add more whiskers and add shiny highlights to the nose and to the top of the head.

Glaze over the white areas with Cream and over darker areas with Yellow Ochre. Do not warm up the gray areas on the cheeks or on top of the head.

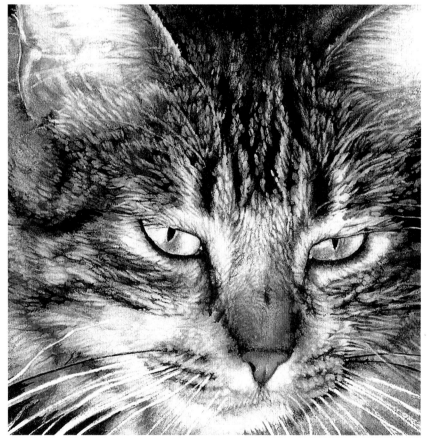

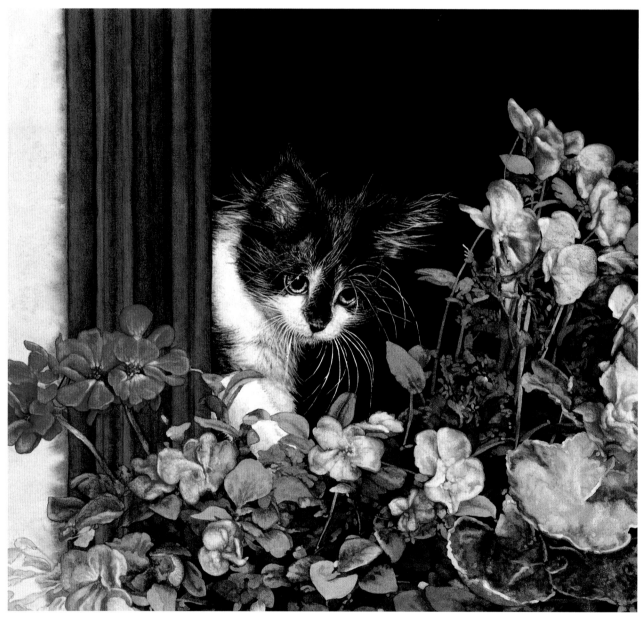

First Bloom

For me, feeling and expression are the most important elements to convey in animal art. Careful observation is the key to painting an animal that really looks alive. What is the animal doing, and why? How does it feel? How are its surroundings affecting its mood? The eyes will tell you a lot. So will the set of the ears, the shoulders, the tail, the back and almost every other part of its body.

I've lived with and studied cats all of my life; they are my favorite animals. Yet with every passing year, I feel less like an expert. The joy of studying makes the goal—being an expert—unnecessary.

FIRST SPRING
10" × 10¾" (25cm × 27cm)

BLACK-AND-WHITE KITTEN

1 Drawing/Inking Step
Complete Drawing, Lay Ink

Use ink and watercolor for the black half of this kitten and the White pencil/Warm Grey acrylic technique for the white half.

Lay ink on only the very darkest part of the black fur—not on the reflections. Leave out all whiskers and the areas over the eyes. Leave a "halo" of lighter fur around the cat's head to separate it from the darker background.

Leave white areas and the reflections in the pupils of the eyes completely free of ink. In general, use ink cautiously and conservatively.

COLORS

WATERCOLOR
Burnt Umber
Charcoal Grey
Hooker's Green
Quinacridone Gold
Raw Umber
Rose Doré
Sepia
Warm Grey Liquid
 Acrylic Color

COLORED PENCIL
Black
Copper Beach
Dark Umber
French Grey 10%
Goldenrod
Sepia
White

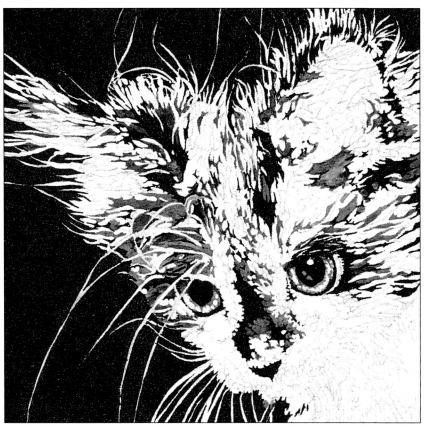

2 Watercolor Step
Paint Darks

Select your next-lighter areas in the black fur and paint them with dark Charcoal Grey, being careful not to cover up whiskers or other white fur.

For the dark green in the eyes, use Hooker's Green mixed with Sepia. The next-lighter eye color is gold, so use strong Quinacridone Gold.

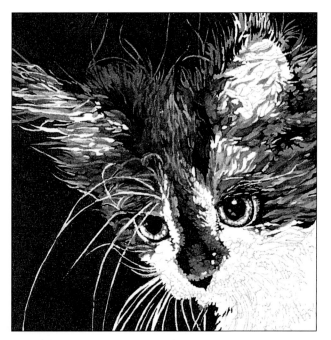

3 Watercolor Step
Start a Grisaille

Add a little water to your Charcoal Grey and fill in your next-lighter area. Then add even more water and cover all the remaining black fur.

Pick out the highlights on the white face and protect them from color by covering them with White pencil. Also, protect the whiskers and the highlights in the eyes.

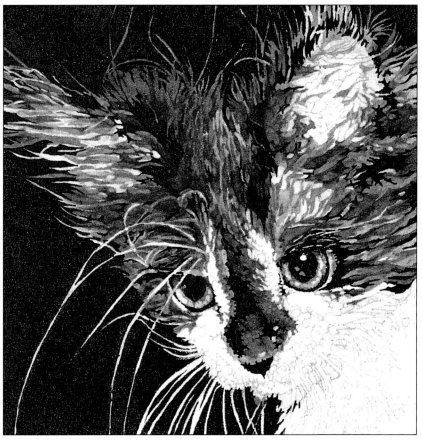

4 Watercolor Step
Build the Grisaille

For your next-lighter areas, wash pale Warm Grey acrylic color over everything but the eyes.

Wash pale Hooker's Green over the irises of the eyes, avoiding the white reflections of the pupils. (Notice that the other reflections have been painted using Charcoal Grey.)

5 Watercolor Step
Finish Grisaille, Develop Features

Determine the next-lighter white areas and cover them with White pencil. Avoiding the eyes, apply another wash of Warm Grey acrylic color over the whole cat. Repeat this process one final time.

Mix Rose Doré with Raw Umber and paint inside the ears, around the eyes and on the nose and mouth.

Paint a light wash of Burnt Umber over all the white areas and above the eyes, where the skin shows. Don't paint over the pink areas.

If necessary, darken any black fur areas with Charcoal Grey.

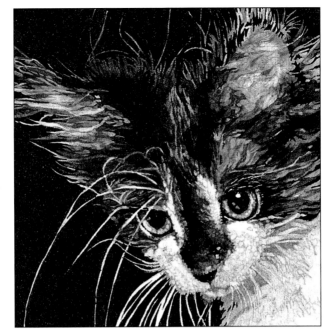

6 Colored-Pencil Step
Final Touches

Erase the white fur and the eyes thoroughly but carefully.

Use Copper Beach pencil to soften the light areas inside the right ear. Blend it with Dark Umber and Black pencil around the edges. In the other ear, add extra wisps of fur with White pencil, and then blend the dark edges with Sepia and Black pencils.

Highlight the forehead, the skin above the eyes and the tip of the nose with French Grey 10% pencil.

To brighten the eyes, add a touch of Goldenrod pencil.

Finally, using a Black pencil, add additional black hairs and darken anything that needs it.

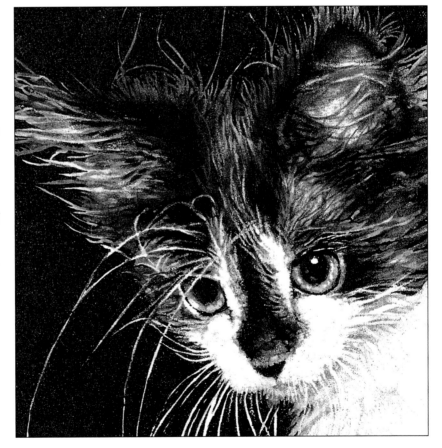

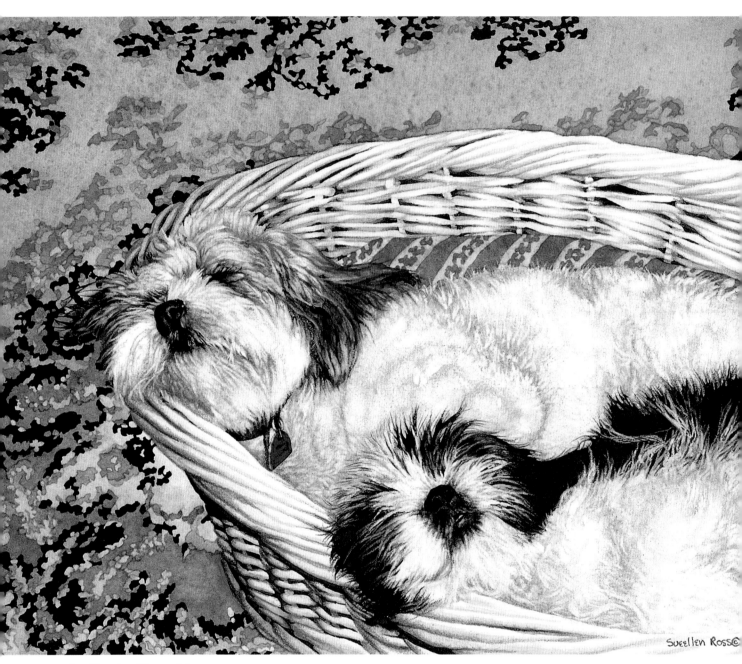

Let Sleeping Lhasas Lie
Nani and Sophie were taking a nap in the middle of a birthday party given by
their owner. Exhausted by all the attention they'd received, they fell into a deep
sleep. I took lots of pictures of them—flash and all—and they never stirred.

Notice that the older dog's coat has been clipped and is short and curly. The
facial hair is straight. The puppy still has its baby coat. All of these fur types
can be done with White pencil, Warm Grey Liquid Acrylic Color and Burnt
Umber watercolor.

Soften and push the blue patterns on the cushion and rug into the background
by applying shadow glazes of French Ultramarine and Burnt Sienna over them.

NANI AND SOPHIE
6" × 8" (15cm × 20cm)

COARSE-HAIRED DOG

1 *Drawing/Inking Step*
Complete Drawing, Lay Ink
Inking is minimal on white or light-colored fur. For this Lhasa Apso, use ink around the eyes, the nose and for the very darkest shadows.

2 *Watercolor Step*
Paint Darks
Use Charcoal Grey watercolor for the very darkest parts of the nose, the ear and the pads of the foot. Cover all but one reflection in each eye with the same color. For the warm brown irises, paint rich Burnt Umber. Paint Raw Umber on the basket's shadow.

3 *Watercolor Step*
Start a Grisaille
Select the next-lighter gray area and paint it in with cool Charcoal Grey. Now switch to Warm Grey Liquid Acrylic Color, and use it almost full strength for your next gray value.

Protect the lightest highlights around the nose and on the forehead by covering them with White pencil.

Dilute your Raw Umber and wash it over the basket.

COLORS

WATERCOLOR
Burnt Sienna
Burnt Umber
Charcoal Grey
French Ultramarine
Raw Umber
Rose Doré
Warm Grey Liquid
　Acrylic Color

COLORED PENCIL
Black
Burnt Ochre
Copper Beach
Cream
French Grey 10%
Goldenrod
Sepia
White

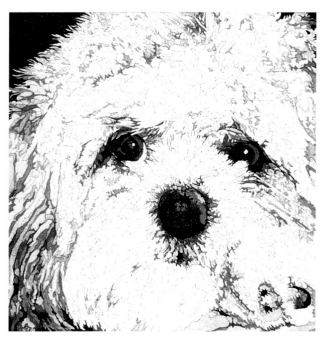

4 *Watercolor Step*
Build the Grisaille

Wash over the face with your first pale wash of Warm Grey Liquid Acrylic Color, avoiding the nose and the eyes. Add a little extra Warm Grey to the darkest areas.

You now have two pale values—the pure White of the pencil and a pale gray.

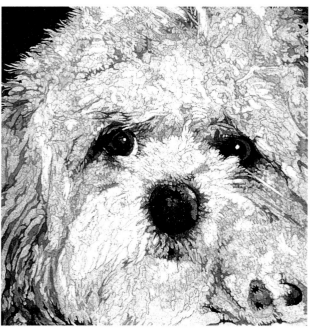

5 *Watercolor Step*
Finish Grisaille

Repeat this process three more times: Select the next-lighter areas; cover them with White pencil; wash over the face with another coat of Warm Grey acrylic. You will see a three-dimensional pale gray face emerging. The White pencil may start to look dirty, but will erase later.

Mix Rose Doré and Raw Umber to paint the foot pad.

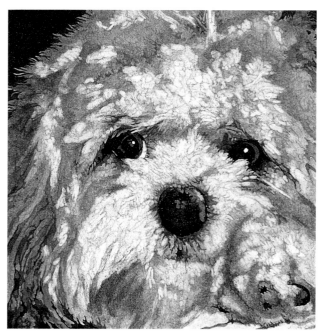

6 *Watercolor Step*
Create Dimension

To pull the light areas of the face forward and to mold the head, add shadows to the face with a mixture of French Ultramarine and Burnt Sienna.

The dog's fur is blue gray in places and cinnamon in others. So, add extra blue to your shadow mix for the gray places, and extra Burnt Sienna for the cinnamon places.

The chin, the upper ear, the area under the left eye and the paw are reddish. Add Burnt Umber to these areas to really warm them up.

7 *Watercolor/Colored-Pencil Step*
Erase, Scrub, Highlight

Erase the whole face thoroughly, getting rid of all traces of graphite. Then, with an old watercolor brush, scrub out areas that have gotten too dark or dirty, and blot up the moisture with tissue.

When the painting is dry, use a White pencil to fill in and soften the lightest clumps of white fur. Add white pencil highlights to the fur and the wicker basket.

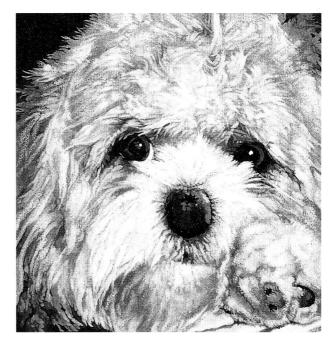

8 *Colored-Pencil Step*
Final Touches

If any fur needs deeper shadows, shade it with Sepia pencil. Brighten the reddish areas with Burnt Ochre pencil, and darken the edges of these areas with Copper Beach pencil blended into Sepia.

Highlight darker gray areas with French Grey 10% pencil blended into Sepia. Sharpen the edges of the eyes and nose with Black pencil.

Finally, glaze the lighter areas with Cream pencil, and touch up the lightest areas with fresh White pencil.

Soften the edges of the basket with Goldenrod pencil.

A Study of Expression and Texture

Contrast Toby's (dog) eager-to-please, slightly sheepish look with Monkey's more guarded one. Notice Toby's wide-open eyes and relaxed facial muscles and Monkey's lowered brow and tense muzzle.

 Their silky black fur is done by breaking up the fur into sharp-edged sections. Fill in the darkest sections with India ink. Then apply gradually lighter shades of color with Charcoal Grey, Sepia and Burnt Umber watercolor, and then use Warm Grey Liquid Acrylic Color and White pencil.

TOBY AND MONKEY
8½″ × 12″ (22cm × 30cm)

SHINY-HAIRED DOG

1 *Drawing/Inking Step*
Complete Drawing, Lay Ink
Highly reflective fur is hard-edged, not fuzzy. Use ink only in those areas that get no light. Break up dark areas into dark, darker and darkest, and ink only the darkest.

COLORS

WATERCOLOR
Burnt Sienna
Burnt Umber
Charcoal Grey
French Ultramarine
Quinacridone Gold
Raw Umber
Rose Doré
Sepia
Warm Grey Liquid
 Acrylic Color

COLORED PENCIL
Dark Umber
French Grey 10%
Light Umber
Sepia
White

2 *Watercolor Step*
Paint Darks
Paint the background with a mixture of French Ultramarine and Burnt Sienna.

Select the next-lighter gray and paint it with Charcoal Grey watercolor, which is almost as dark as the ink. Use this same color to paint around a single, round white reflection in the left eye. This focuses the gaze and makes the eye look round.

Paint the eyes (one is partially hidden in the fur—don't miss it) with heavy Quinacridone Gold.

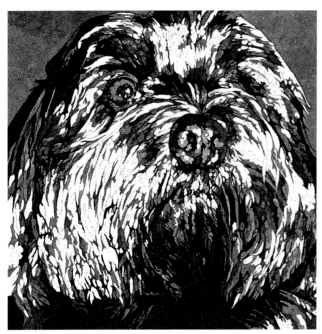

3 Watercolor Step
Add More Darks, Pencil Resist

Paint your next-lighter gray with slightly lighter Charcoal Grey.

Switch to Sepia. Add enough water so that it is lighter than your last application of Charcoal Grey, and use it extensively as the next-lighter value.

Protect a few highlights on the forehead and cheeks by covering them with White pencil.

4 Watercolor Step
Paint Lighter Colors

Watered-down Sepia is a beautiful, cool gray-brown. Use it extensively as your next-lighter color.

Do a wash of pale Charcoal Grey over the nose, and knock back the lower-right area of the painting with a wash of the same color.

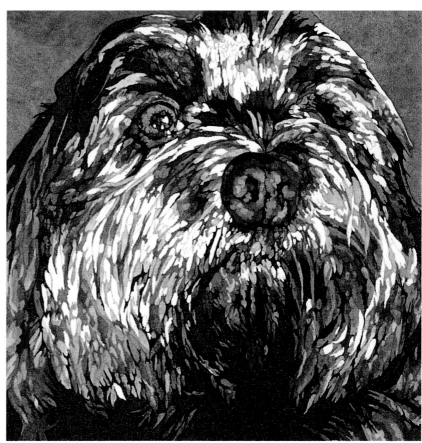

5 *Watercolor Step*
Warm Up and Highlight Fur

Wash pale Burnt Umber over all the face, except for the eyes and nose.

Pick out and protect the next-lighter highlights from further color by covering them with White pencil.

Wash over all the fur with pale Warm Grey acrylic. This blends and softens all the colors.

With medium-dark Sepia, go back and deepen any areas that you want darker.

If you like, add a touch of pink to the inside of the nostrils with Rose Doré mixed with Raw Umber.

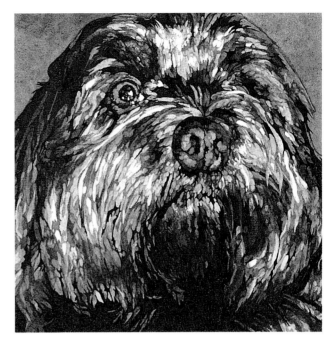

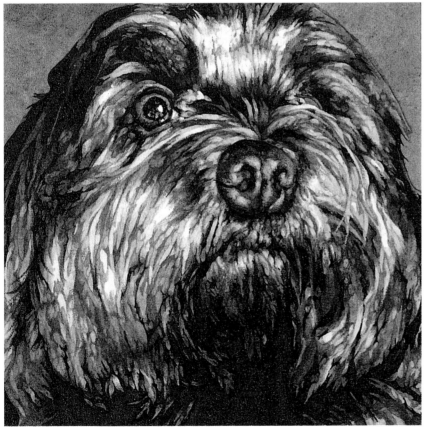

6 *Colored-Pencil Step*
Final Touches

Erase any visible graphite.

Highlight the nose with White pencil, blending the edges with Sepia pencil. Use French Grey 10% pencil for all fur highlights, blending them into the darker areas with Light Umber or Sepia pencils. Blend any sharp edges on the rest of the fur with the same colors, using Light Umber for the lighter areas and Sepia for the darker ones.

Soften the outside edges of the gold eyes with Dark Umber pencil.

WILD MAMMALS AND BIRDS

Step by Step

If you paint animals, be as true to their real natures as you can. You can do this by painting only animals and birds that you know very well. (I've done this more and more as time goes on.)

If you want to portray an animal that you're not as familiar with, find out everything you can about it before you attempt a painting. Observe it in the wild. If you can't, go to zoos and game farms, aviaries and aquariums. Study your subject closely. Sketch and take photos. Read field guides. Do everything you can to become familiar with your subject.

Then, try to get the essence of that subject into your work. Pay particular attention to mood and expression and posture. All the skill in the world won't help if you can't breathe life and character into your subject.

EYE OF THE BEHOLDER
7″ × 11″ (18cm x 28cm)

Every Little Feather
Just how much detail should an artist put into a painting? Some thrill to the words "It looks just like a photograph!" Some, on the other hand, feel that the "looser" a painting is, the more "artistic" it is.

I normally do not paint "every little feather," as I did in *Eye of the Beholder*. However, it was fun seeing just how far I could go with the ink, then with the watercolor and, finally, with the colored pencil.

As you can see, this technique allows you to get very detailed. Notice the shape of the reflection in the eye. Notice the hair-like black feathers in the eye ring and the deep shadows between the feathers at the bottom. Notice the heavy shadow cast by the brow and the bars on the forehead feathers. All of these were done in ink before any color was added. Ink makes detailing every little feather much easier.

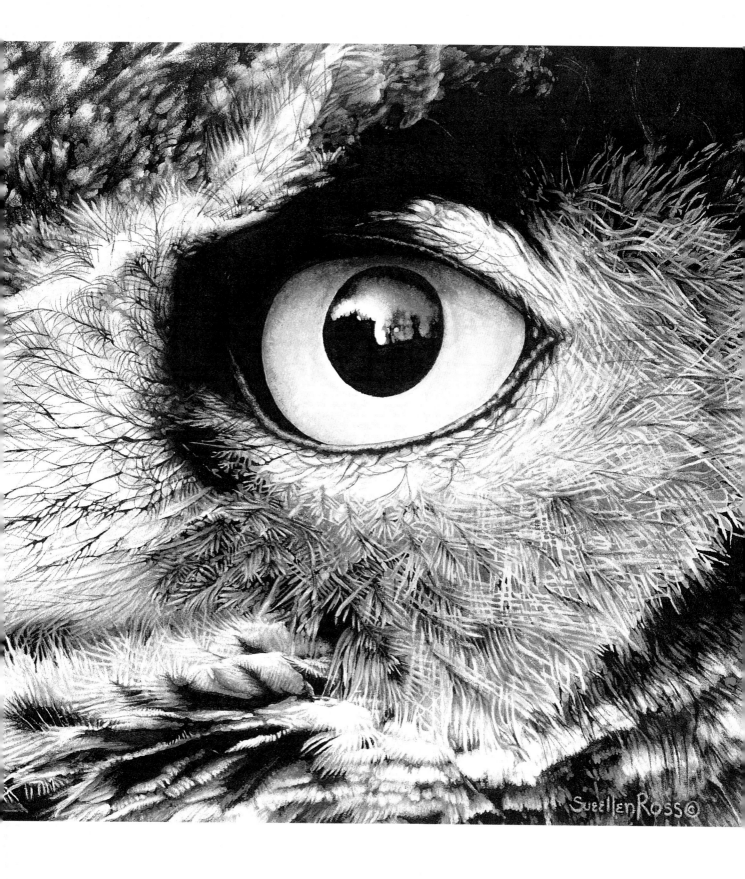

SueellenRosso©

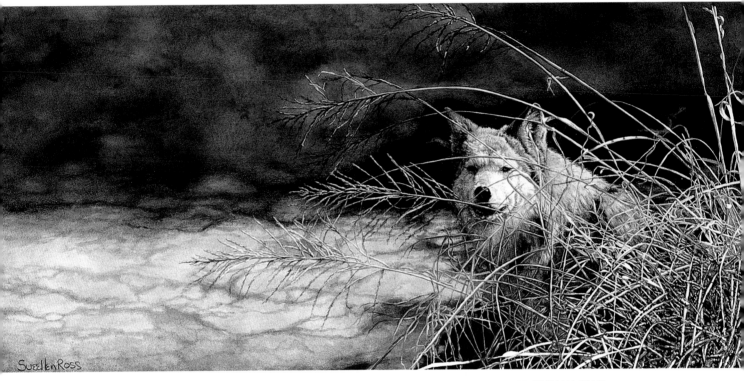

Painting Wolves

This red wolf lives at the Desert Museum outside of Tucson. Since I have never seen a wolf in the wild, I must rely on zoos, game farms and preserves to observe this magnificent animal.

The wolf is a perfect subject for learning fur techniques. From the soft, white fur on the muzzle and legs to the red fluff on the ears, from the coarse, long ruff to the glossy, black-tipped fur on the back, each section needs to be approached differently.

A tip for our "dead giveaway" department: Captive wolves often have carefully clipped toenails. Lengthen and taper them, so the wolf you paint is free to live anywhere in the viewer's imagination.

DESERT SHADOWS
10¾" × 24½" (27cm × 62cm)

WOLF

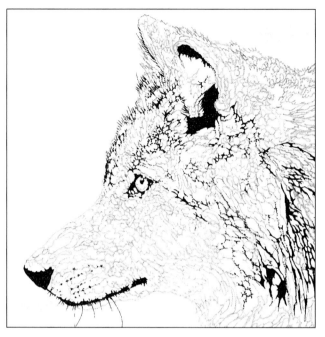

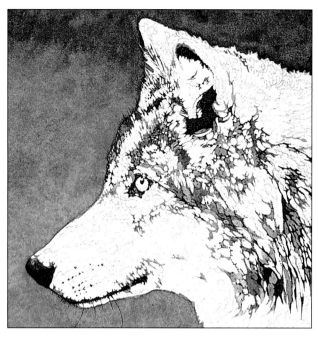

1 Drawing/Inking Step
Complete Drawing, Lay Ink

The fur behind a wolf's ears is very different in texture and color from that on its back, its tail, its muzzle, belly or legs. A gray or red wolf will have some black in each of these areas.

Do a very detailed graphite drawing, and distinguish each type of fur from the others. For black-tipped fur, use stippling. For heavy, coarse fur, use ink in the shadows between clumps.

Take special care when drawing and inking the eyes; what you do now will set the mood and expression of the animal. Here we want the expression to look cool and dispassionate, yet alert and interested.

2 Watercolor Step
Paint Background and Darks

A background wash of French Ultramarine mixed with Burnt Sienna looks a bit like the sky and a bit like bare earth. While the wash is still wet, add a darker streak of the same color at the top.

Pick out the areas of fur that are almost as dark as the ink, and paint them with Charcoal Grey watercolor. Add some water to this color, and paint the next-lighter color.

COLORS

WATERCOLOR	COLORED PENCIL
Burnt Sienna	Black
Burnt Umber	Burnt Ochre
Charcoal Grey	Cream
French Ultramarine	French Grey 10%
Hooker's Green	Light Umber
New Gamboge	Olive Green
Quinacridone Gold	Orange
Warm Grey Liquid	Sepia
Acrylic Color	White

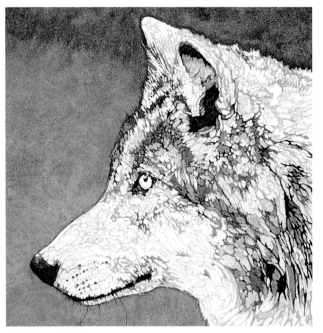

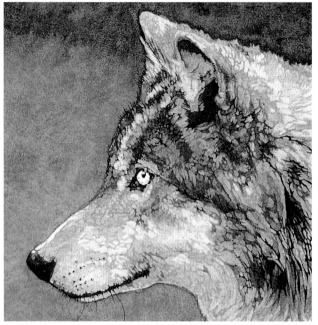

3 Watercolor Step
Build a Grisaille

The next-lighter gray is Warm Grey Liquid Acrylic Color. Use it almost full strength, for a warm, midtone gray.

Pick out the lightest areas of fur, and cover them completely with White pencil. Dilute your Warm Grey acrylic with water, and paint a pale wash of it over the whole animal except the eyes.

4 Watercolor Step
Finish the Grisaille

With a White pencil, cover the next-lighter areas, and wash over everything except the eyes with pale Warm Grey acrylic. Repeat this process twice.

Now you have a whole range of gray, from black to white. Next, glaze over everything except the eyes with a pale wash of Burnt Umber watercolor.

Do any of the darks look wimpy or washed out? If so, punch them up with a fresh, dark application of Charcoal Grey.

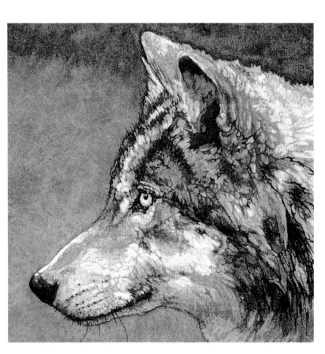

5 Watercolor Step
Paint Bright Colors

For those pale, eerie eyes, paint pale green (straight Hooker's Green) on the top, and pale Quinacridone Gold on the bottom. Add a ring of darker Quinacridone Gold on the bottom and right side of the eye. Leave a pure white highlight in the front of the pupil.

Add color to the coat. Mix Burnt Sienna with New Gamboge, and glaze the backs of the ears and the top of the nose. Dry brush additional dark strokes of Charcoal Grey watercolor where needed.

Once dry, erase the whole wolf, right down to the paper, getting rid of all the graphite and White pencil.

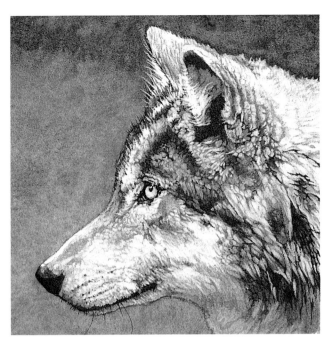

6 Colored-Pencil Step
Add Lights

On all the lightest fur, use White pencil to soften edges, to fill in and to connect the clumps of fur. (You'll be glazing over these areas later with warm colors.)

For the slightly darker areas, do the same thing with French Grey 10% pencil.

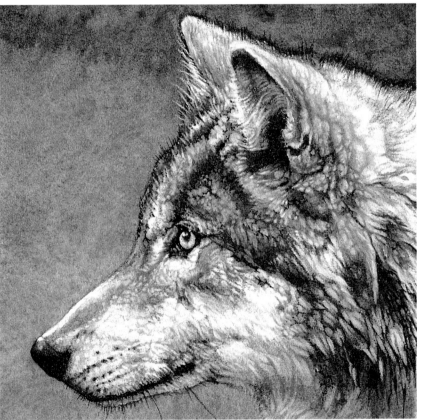

7 Colored-Pencil Step
Warm and Blend

Glaze over the White pencil on the ears with Cream pencil, and use Burnt Ochre pencil to heat up the shadows between clumps of red fur. Shade the muzzle, the cheeks and around the eye with Sepia pencil. Add more texture to the light fur on the muzzle and back with Light Umber pencil.

Add highlights to the fur in shadow (inside the ears and on the neck) by drawing in fur texture with French Grey 10%. Put some dark tips back into the light fur with Sepia.

Soften the ink edge of the pupil with Olive Green pencil. Warm the ears further with Orange pencil, and add black tips with Black pencil.

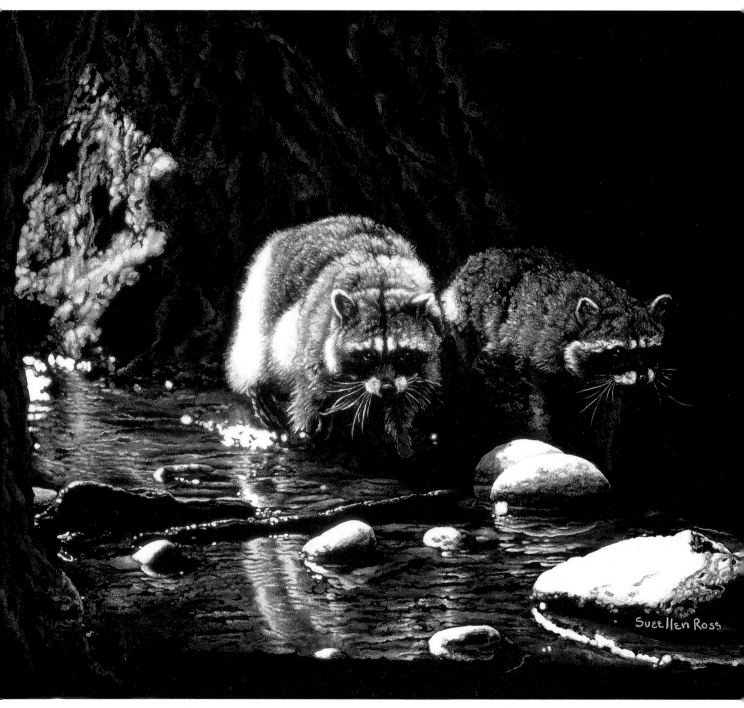

Exploring a Cave

India ink plays an important role in this painting. In fact, very little of the right-hand raccoon emerges out of the ink that surrounds it. You can use India ink for the entire cave, the darkest parts of the water, the shadows in the rocks and the masks, legs and tipped fur of the animals.

Use Burnt Umber watercolor for the brown water. Use the White pencil and Warm Grey acrylic technique for the soft, pale parts of the raccoon fur.

You can complete everything else with colored pencil, including the texture of the rock in the cave, the soft edges of the fur, the vegetation clinging to the rocks outside the cave and the reflections on the water.

IN THE SHADOWS—RACCOONS
12″ × 14″ (30cm × 36cm)

RACCOON

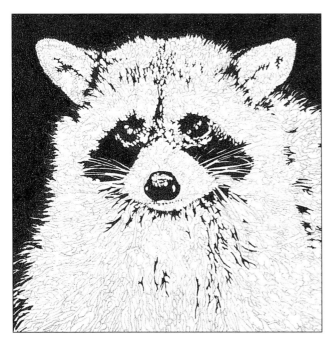

1 Drawing/Inking Step
Complete Drawing, Lay Ink

You'll get to practice several inking techniques on this critter.

Leave the whiskers and the shiny areas free of ink in the black areas. Use ink in the darkest shadows between clumps of fur. Try stippling for a salt-and-pepper, tipped look to the fur. Raccoons have long, soft fur, so these areas will be small and delicate.

Raccoon eyes are very dark. Do them with ink, leaving several highlights in each. Where you put the highlights will determine the animal's expression. Try for a curious but cautious look.

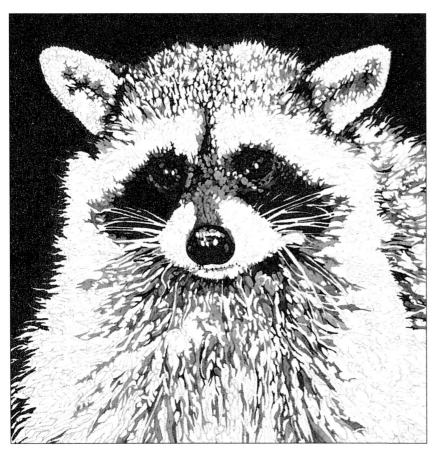

2 Watercolor Step
Paint Darks

Select the darkest shadows between clumps of fur and fill them in with dark Charcoal Grey watercolor. Add a bit of water to your paint, and select and paint the next-lighter areas.

Make sure the whiskers stay white.

Cover all but two highlights in each eye with dark Charcoal Grey.

COLORS

WATERCOLOR
Burnt Umber
Charcoal Grey
Sepia
Warm Grey Liquid
 Acrylic Color

COLORED PENCIL
Black
Copper Beach
Dark Umber
French Grey 10%
Sepia
Slate Grey
White
Yellow Ochre

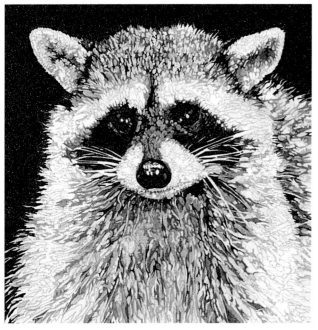

3 *Watercolor Step*
Build a Grisaille
Select the very lightest fur and protect it from further color by covering it with White pencil. Switch from cool Charcoal Grey to Warm Grey Liquid Acrylic Color. Use it almost full strength.

Wash over everything except the eyes with a pale wash of Warm Grey acrylic.

4 *Watercolor Step*
Finish Grisaille
Select the next-lighter grays (you are up to the midtone grays now) and paint them in with Warm Grey Liquid Acrylic Color.

With White pencil, protect the next-lighter fur areas. Wash over everything again with pale Warm Grey acrylic.

Glaze over everything, except the eyes, with pale Burnt Umber watercolor, and touch up wimpy, faded areas with a Charcoal Grey and Sepia watercolor mix.

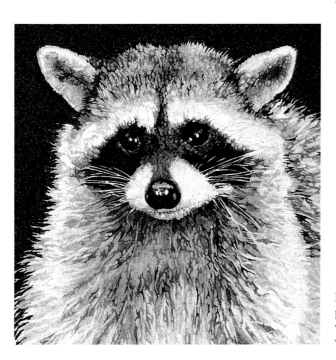

5 *Watercolor Step*
Erase and Repair
Erase all traces of graphite and White pencil. If the ink areas look shiny, wash over them with Charcoal Grey watercolor.

6 Colored-Pencil Step
Add Lights

Using White pencil, cover all the pure white fur. Clean up the whiskers and fluff and soften the edges of the white fur.

Connect and whiten the long hairs on the white fur in the salt-and-pepper areas.

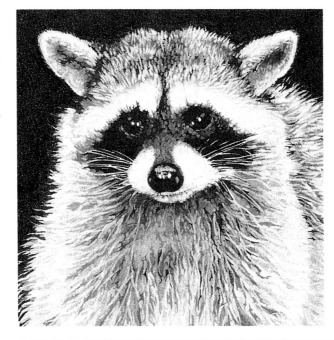

7 Colored-Pencil Step
Warm and Add Details

In the ears, soften the ink edges and warm up the color, first with Dark Umber, then Copper Beach pencils.

Highlight the mask with French Grey 10% pencil. Blend this gray into the black with Sepia pencil.

Add Black pencil around the eyes. Make the eyes look bright and round by highlighting the lower lid with White pencil. Leave one white highlight in each eye, and put Slate Grey pencil on the other one.

If you want to knock back any of the salt-and-pepper areas of fur, glaze over them with a little Sepia, but leave some white showing through.

Add a few warm highlights around the edges of the white face and brow with Yellow Ochre pencil. Don't allow the white to get dirty.

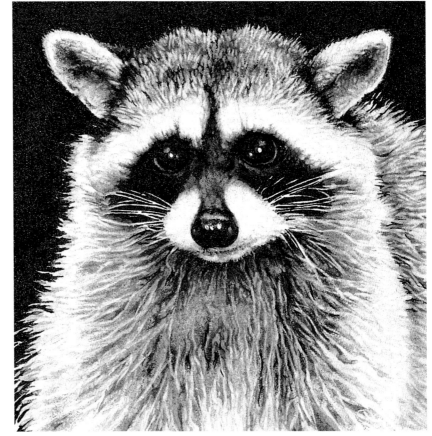

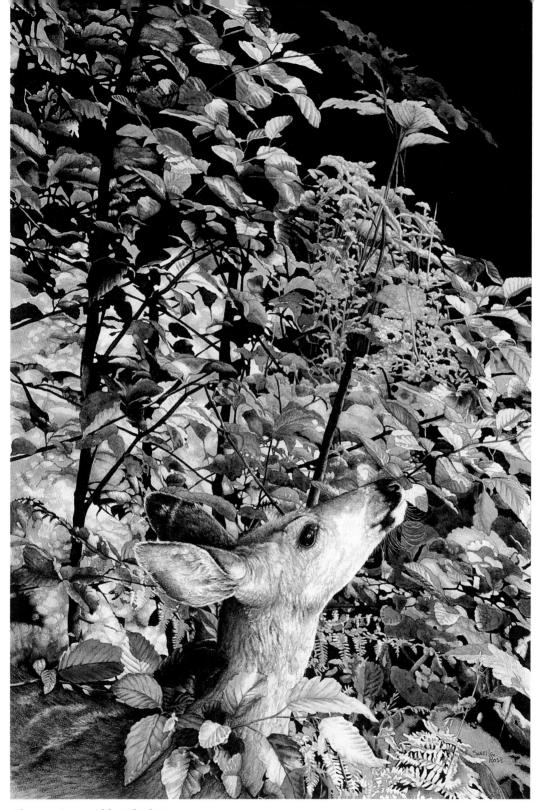

DAPPLED DOE
21" × 14" (53cm × 36cm)

Close-up in an Alder Thicket

Mule deer have absolutely beautiful faces, with very large eyes and ears and sweet little black-and-white muzzles. Most painters like to picture them in action, in groups or at a distance. In *Dappled Doe* I've zoomed in on the face; a doe calmly selects a tender alder leaf to munch on.

Use ink in the eye, muzzle and ear tips. White pencil and Warm Grey acrylic work well for the pale fur on the face. You can complete the rest of the fur with Raw Umber and Burnt Umber watercolor.

DEER

COLORS

WATERCOLOR
Burnt Sienna
Burnt Umber
Charcoal Grey
Hooker's Green
New Gamboge
Quinacridone Gold
Raw Umber
Rose Doré
Sepia
Warm Grey Liquid
 Acrylic Color

COLORED PENCIL
Black
Burnt Ochre
Copper Beach
Dark Umber
Light Umber
Orange
Sepia
Vermillion
White
Yellow Ochre

1 *Drawing/Inking Step*
Complete Drawing, Lay Ink

Decide where the backlighting will spill over the doe's shoulder. Put as much detail into the short fur as you can with graphite.

Very little ink will be needed on this pale, even-colored deer. Be careful, though, to leave highlights free of ink in the dark eyes and nose. The whiskers should be white, too.

2 *Watercolor Step*
Paint Background and Darks

For the background wash, load a big brush with a mixture of Hooker's Green and Sepia watercolor. Keeping your lead edges wet, carefully paint around the fur as you encircle the deer with green.

Select the areas of the fur that are almost as dark as the ink, and fill them in with dark Charcoal Grey watercolor. Do two more shades of dark gray, adding water to your paint each time.

Leave the whiskers white.

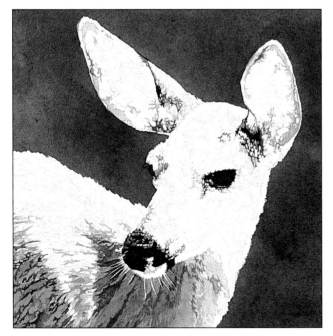

3 *Watercolor Step*
Build a Grisaille

Switch from cool Charcoal Grey to Warm Grey Liquid Acrylic Color for the next-lighter areas. Add just a little water to your paint; you want a rich, midtone gray.

The very lightest areas of fur should now be protected from further color using White pencil. (Don't forget the whiskers.) When you've covered all the lightest fur, do a pale wash of Warm Grey acrylic over the whole deer, avoiding the eyes.

To even up all the gray colors and to darken them further, add a final dark wash of Warm Grey acrylic.

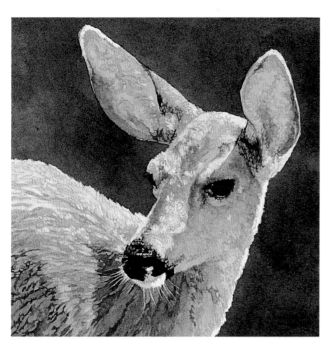

4 *Watercolor Step*
Finish Grisaille

Paint in two more shades of dark Warm Grey Liquid Acrylic Color. (Add a bit of water to lighten your paint each time.)

With White pencil, protect the next-lighter fur areas. Once they're covered, paint over the whole deer, except the eyes, with pale Warm Grey acrylic.

Select the next-lighter areas, protect them with White and do a final wash of Warm Grey acrylic over the entire deer except the eyes.

Glaze pale Burnt Umber over all the fur, and add extra Charcoal Grey to any shadows that need more depth.

5 *Watercolor Step*
Paint Bright Colors

For a warm, backlit look, glaze pale Quinacridone Gold over the ears. Paint a strong mixture of Rose Doré and Raw Umber over the gold. The heat of the gold will come through.

Except for the pure white areas, wash the rest of the fur with Raw Umber watercolor.

Warm up spots on the ears, the forehead, the sides of the nose and on the back with a mixture of Burnt Sienna and New Gamboge.

Use Sepia to drybrush darker details anywhere they're needed. Use a good, medium-sized brush with a good point to add feathery details to the fur.

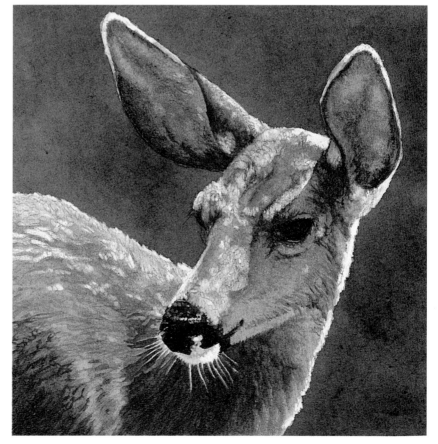

6 Colored-Pencil Step
Add White Highlights

Working directly over your watercolor, draw in light, high-lighted fur with White pencil. Add extensive texture to all the light areas. Try to make your pencil strokes short, as the deer's fur is short and coarse.

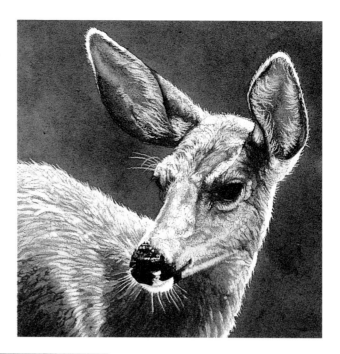

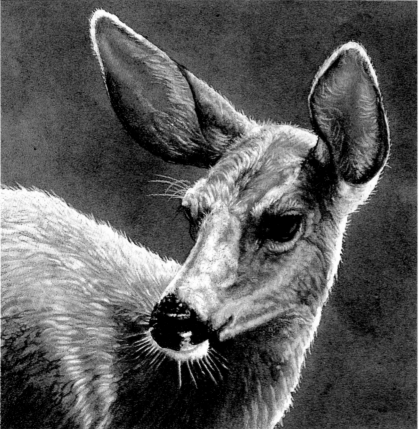

7 Colored-Pencil Step
Go Warmer and Darker

Glaze over the white fur in the ears with Copper Beach pencil. Shade the edges of the ears with Dark Umber pencil, and brighten them with Orange and Vermillion pencils. Blend all these colors in the ears with Copper Beach.

In the light areas of the fur, glaze over the White pencil with Light Umber pencil. Use Sepia pencil to glaze over the darker areas.

Add highlights in the eyes with Burnt Ochre, and darken around them with Black pencil. Sharpen up the edges of the nose with Black pencil.

Use Burnt Ochre and Orange to further brighten the top of the head. Glaze everywhere on the deer (except for the cool bridge of the nose) with Yellow Ochre pencil.

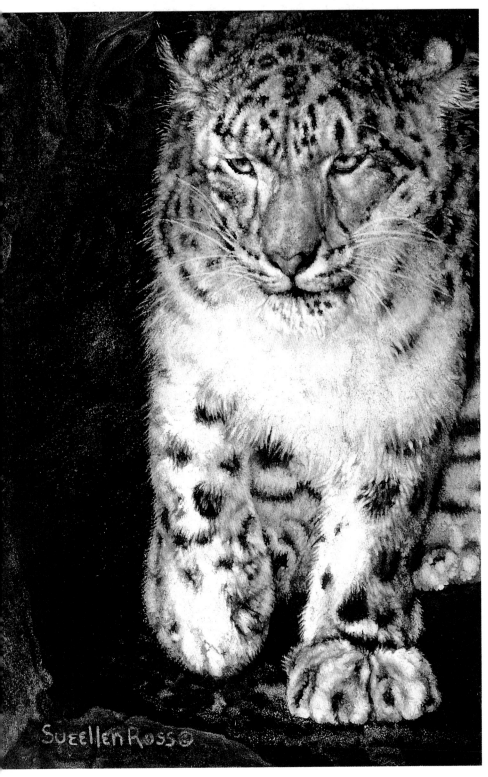

SNOW LEOPARD
7⅜" × 5⅛" (19cm × 13cm)

Emerging From Shelter

A snow leopard cautiously leaves the shelter of a cave—ears picking up every sound, eyes adjusting to the bright light and feet silently padding on the cave floor. She may look a little distracted, but she's not. She is very much aware of her surroundings.

Of the big cats, snow leopards show off our mixed-media technique best. They are the color of silvery moonlight—warm, pearly gray with peachy overtones. White pencil, used with Warm Grey Liquid Acrylic Color and Burnt Umber watercolor, matches this color perfectly.

Notice the difference in texture between this full-grown snow leopard and the juvenile in the following step-by-step demonstration. Here the chest fur is long, straight and silky, not clumped and downy like the young cat's.

Paint the black spots with India ink. Use Charcoal Grey watercolor on the other dark areas. Paint the eyes a pale Payne's Grey, glazed with pale Quinacridone Gold. Olive Green and Goldenrod pencils give them depth and a bit of warmth.

Use Rose Doré with Raw Umber watercolor for the nose. Soften the fur with White, Sepia, Raw Umber and Yellow Ochre pencils.

Paint the background cave with India ink, and add details with French Grey 10% and Sepia pencils.

SNOW LEOPARD

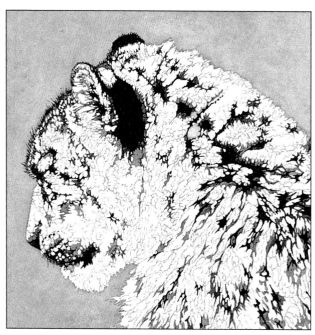

1 *Drawing/Inking Step*
Complete Drawing, Lay Ink

This young snow leopard still has its baby fur. The fur is soft and wooly and separates into clumps. Draw the clumps with graphite, and locate the darkest parts of each spot.

Use ink for the centers of the spots and for the deepest crevices in the fur. Notice the tipped fur on the forehead; use stippling here.

2 *Watercolor Step*
Paint Background and Darks

The background is a pale wash of Payne's Grey. Use lots of water in the paint, and proceed from the upper right and around the head. Use a fully loaded brush with a good point, and carefully go around all the fur edges.

Now select the areas of the fur that are almost as dark as the ink and paint them with dark Charcoal Grey watercolor. Then add a little water to your paint, and paint the next-lighter areas.

COLORS

WATERCOLOR
Burnt Umber
Charcoal Grey
Payne's Grey
Warm Grey Liquid
 Acrylic Color

COLORED PENCIL
Black
Cream
Light Umber
Sepia
White
Yellow Ochre

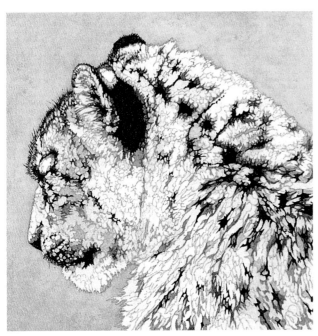

3 *Watercolor Step*
Build the Grisaille

Switch to Warm Grey Liquid Acrylic Color and apply it almost full strength to the next-lighter areas of the fur. Then select the very lightest spots on the fur, and cover them thoroughly with White pencil.

Paint a pale wash of Warm Grey acrylic over the whole cat.

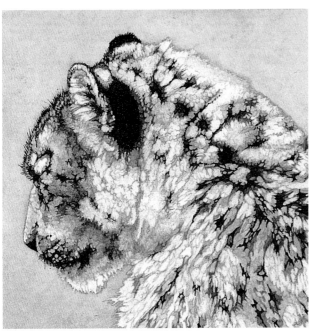

4 *Watercolor Step*
Finish the Grisaille

Repeat the last step with Warm Grey Liquid Acrylic Color and White pencil. Then touch up the whole drawing using extra White pencil to fluff up the fur and lighten it.

Glaze over the whole cat with pale Burnt Umber watercolor. Darken the face as needed with Charcoal Grey watercolor.

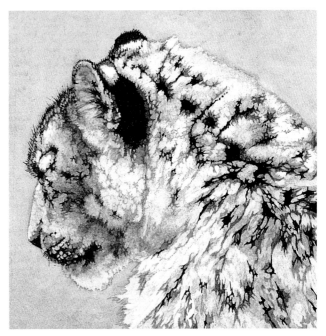

5 *Watercolor Step*
Erase and Edit

Thoroughly erase the graphite and White pencil. Adjust any faded areas by adding more Charcoal Grey watercolor. Touch up the ink where it faded during the erasing.

Paint Charcoal Grey over the ink to dull its shine.

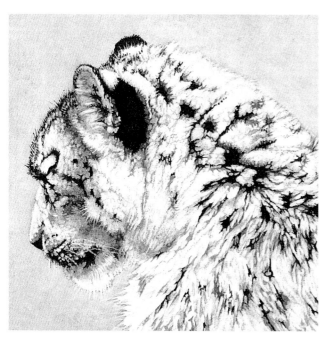

6 Colored-Pencil Step
Add Lights

Go over all the lightest fur with White pencil, softening the edges, filling in and connecting the clumps. Add guard hairs and whiskers with White.

Your original graphite drawing has "engraved" lines into the paper. These will guide you as you work over them.

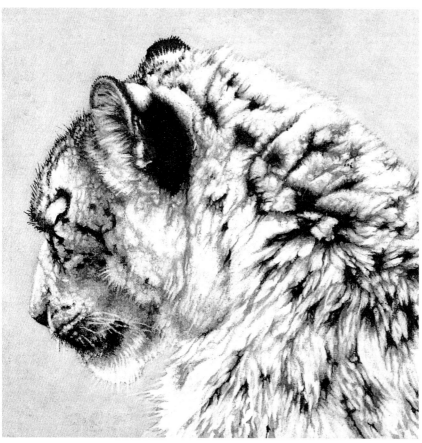

7 Colored-Pencil Step
Add Darks and Details

Soften the ink edges with Sepia pencil in the dark areas and with Light Umber pencil in the lighter ones. Shade the deepest shadow on the face with Sepia.

In the warmer areas, glaze the light fur with Cream pencil. Add extra warmth where you want it by glazing with Yellow Ochre pencil.

Deepen the black spots with Black pencil, and do a last-minute clean-up of the light areas with White pencil.

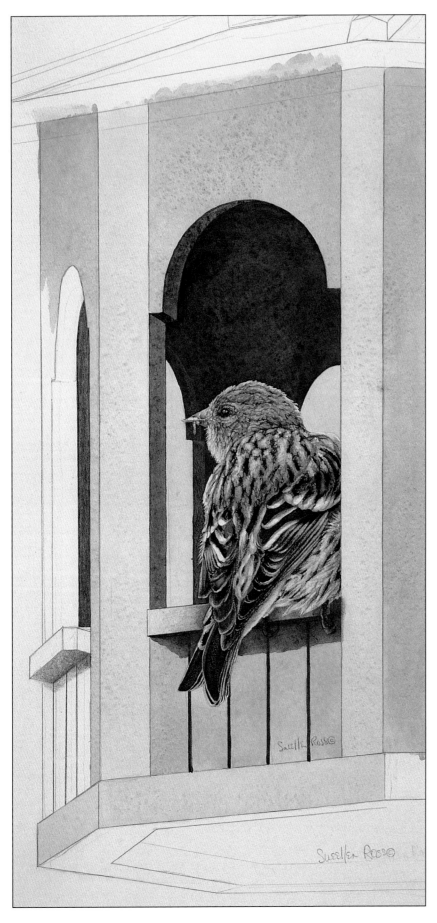

Little Brown Bird
This siskin is all fluffed up to keep warm. He has big, dark eyes, a notched tail, and yellow on the wings and tail. Though his head and back look brown from a distance, there is black throughout, which I've put in with ink.

If you're going to get close up and detailed, make sure you've got all the feathers in the right place. Here, the wings are folded; the flight feathers are neatly stacked on top of each other—first the primaries, then the secondaries, the scapulars and tertials. This results in the bulge you see in the shoulders.

A matching set of tail feathers is neatly stacked on each side of the siskin's forked tail.

CHILLY DAY—PINE SISKIN
17¾″ × 8⅜″ (45cm × 22cm)

PINE SISKIN WING

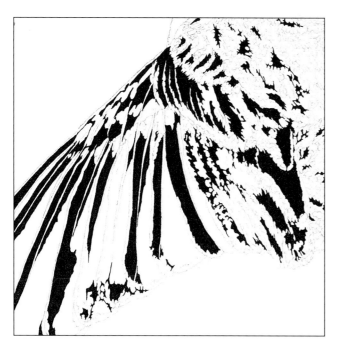

1 Drawing/Inking Step
Complete Drawing, Lay Ink

Carefully detail each feather in your graphite drawing. Then, using ink, fill in the darkest shadows between the feathers and the dark areas along the spines of the big, dark feathers.

The feathers on the back are barred; select only the very darkest part of the stripes and fill those in with ink.

COLORS

WATERCOLOR
Aureolin
Burnt Umber
Neutral Tint
Payne's Grey
Sepia
Warm Grey Liquid
 Acrylic Color

COLORED PENCIL
Canary Yellow
Cream
French Grey 10%
Light Umber
Sepia
White
Yellow Ochre

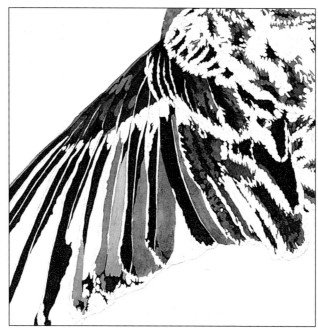

2 Watercolor Step
Paint Background and Darks

Paint the background with a pale Payne's Grey wash. Carefully paint around the light feathers at the bottom of the wing.

Select the darkest areas (after ink) of each wing feather and fill these in with dark Sepia watercolor. Then add a bit of water to your paint, and fill in your next-lighter areas.

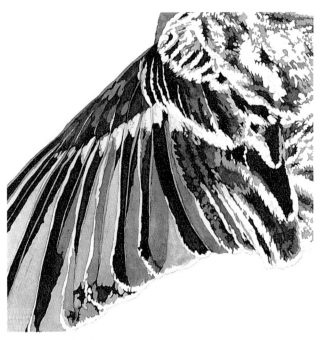

3 *Watercolor Step*
Add Lighter Colors

Add even more water to your Sepia, and fill in your midtone browns on the wing feathers and on the back feathers.

Paint all visible feather spines (quills) with Neutral Tint watercolor.

Use two shades of Aureolin on the yellow areas. Start with a light yellow, and then paint a heavier concentration of the same color in the shaded yellow areas.

4 *Watercolor Step*
Build the Grisaille

Deepen the Sepia on the wings and wherever it needs adjusting. Paint nearly full strength Warm Grey Liquid Acrylic Color as your next-lighter color on the remaining feathers. Shade the pale feathers with this gray. Then add a bit of water to the gray, and cover all the back feathers, leaving highlights on each feather free of color.

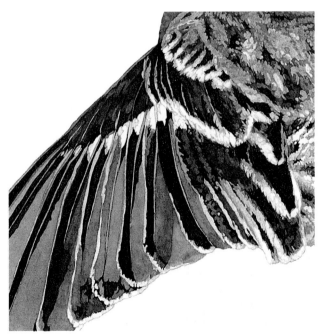

5 *Watercolor Step*
Finish the Grisaille

Wash pale Burnt Umber over all the back feathers. Then shade the darker areas of those feathers with a heavier concentration of the same color.

Cover the very lightest areas on the wing and underbody feathers with White pencil to protect them from further color. Wash all the gray parts of the feathers with a pale solution of Warm Grey Liquid Acrylic Color.

Add Aureolin over the gray along the sides of any feathers that need yellow.

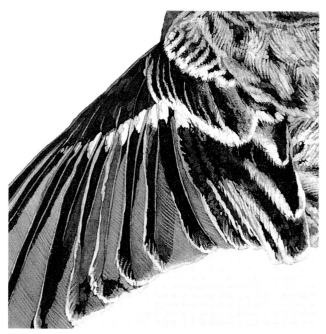

6 Colored-Pencil Step
Add Lights

Erase all the graphite and White pencil.

Using White pencil, soften and fluff all the edges of the lightest feathers. Add all the soft, long feathers on the back and underbody.

With French Grey 10% pencil, highlight the spines (quills) on the wing feathers. Use the same pencil to draw in the barbs along the sides of the feathers.

7 Colored-Pencil Step
Finish Wing

Soften all ink edges with Sepia pencil in the darker areas and with Light Umber pencil in the lighter ones. Use Sepia to soften the barbs that are done in French Grey 10% pencil.

Soften the yellow edges of the wing feathers with Light Umber pencil. Add White pencil highlights to the yellow spots and shade these with Canary Yellow pencil. Add extra Canary Yellow to feathers that have a yellow edge.

Glaze all white feather edges with Cream pencil. This will blend, soften and warm the feathers.

8 Colored-Pencil Step
Finish Body

To shape the pale, fluffy back feathers, glaze the areas closest to the base of each with Sepia pencil. Blend this into the Light Umber, leaving the highlights and edges of the feathers very light.

Add a touch of Canary Yellow pencil along the feather edges closest to the wing. Glaze the back feathers with Yellow Ochre pencil.

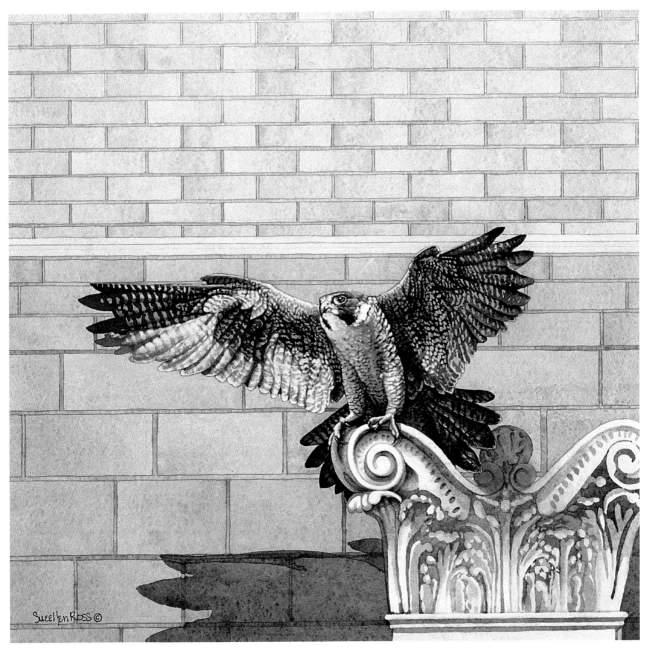

Seattle's Pioneering Peregrines

Peregrine falcon populations have increased so promisingly that the bird is no longer on the endangered species list. Yet it was only a few years ago that Seattle's first falcon couple called a skyscraper home and fed its babies on local pigeon.

Here is one of Seattle's finest, perched on the façade of a University of Washington building.

Paint the bricks and pedestal with varying mixtures of French Ultramarine and Burnt Sienna. Complete the bird with a combination of India ink, White pencil, Warm Grey Liquid Acrylic Color and Burnt Umber and Charcoal Grey watercolor. Color the feet, orbital region and cere with White, Cream, Canary Yellow and Goldenrod pencils.

CITY WINGS—PEREGRINE STUDY
12¼" × 12½" (31cm × 32cm)

PEREGRINE FALCON

1 Drawing/Inking Step
Complete Drawing, Lay Ink

Once your graphite drawing is complete, apply India ink away from the source direction of the light, placing your heaviest concentrations of ink in the shadow of the brow, on the back of the head and in the shadow made by the wing.

Leave highlights and room for color in the dark eye.

COLORS

WATERCOLOR
Burnt Umber
Charcoal Grey
Hooker's Green
Neutral Tint
Quinacridone Gold
Sepia
Warm Grey Liquid
 Acrylic Color

COLORED PENCIL
Black
Burnt Ochre
Cream
French Grey 10%
Goldenrod
Sepia
White
Yellow Ochre

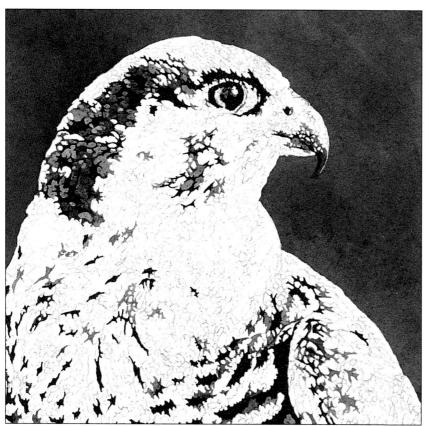

2 Watercolor Step
Paint Background and Darks

Mix Hooker's Green and Sepia watercolor. Apply it generously to the background, starting from the lower right and going carefully around the bill and head. For control, use a fully loaded brush with a good tip.

Select the very darkest places (besides the ink) on the bird, and paint them with dark Charcoal Grey watercolor. Add a bit of water to your paint, and fill in your next-lighter areas. Cover the middle highlight in the eye with this color.

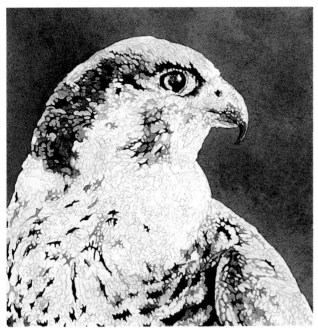

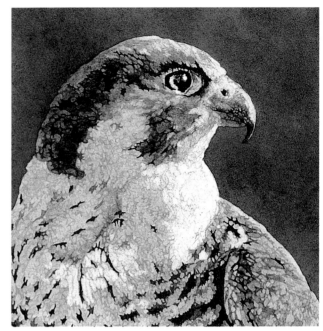

3 ***Watercolor Step***
Build a Grisaille

Switch from cool Charcoal Grey to Warm Grey Liquid Acrylic Color. Select your next-lighter areas, and paint them with nearly full strength Warm Grey acrylic.

Select the very lightest areas on the bird, and cover them with White pencil. Then wash pale Warm Grey acrylic over the whole bird, avoiding the eyes and the green background.

4 ***Watercolor Step***
Finish the Grisaille

Paint the next-lighter areas with Warm Grey Liquid Acrylic Color. Select your next-lighter areas, cover them with White pencil and wash over the whole bird, except the eye, with pale Warm Grey acrylic.

Touch up your light areas with additional White pencil as needed. Then wash the whole bird, except the eye, with pale Burnt Umber watercolor.

Add Neutral Tint to the beak. Add a touch of Charcoal Grey to the cap on the head, and drybrush more detail into the white chest feathers with the same color.

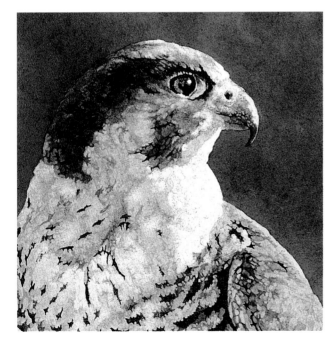

5 ***Watercolor Step***
Finish Watercolor

To add color to the eye, paint a crescent of strong Quinacridone Gold on the left side of the eye. If necessary, darken any shadows with Charcoal Grey watercolor.

Erase all the graphite and White pencil. With an old, soft, wet brush, scrub out some pale, round areas in the shaded feathers.

6 Colored-Pencil Step
Add Lights

Clean up the light feathers with White pencil. Using the same pencil, round out some of the feathers in shadow and soften, even up and define the feather edges.

Sharpen the edges of the bill with White pencil.

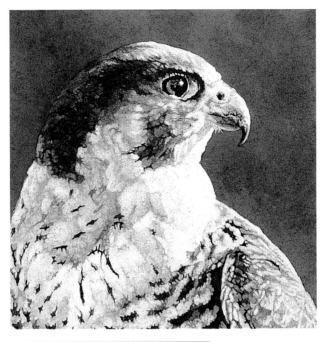

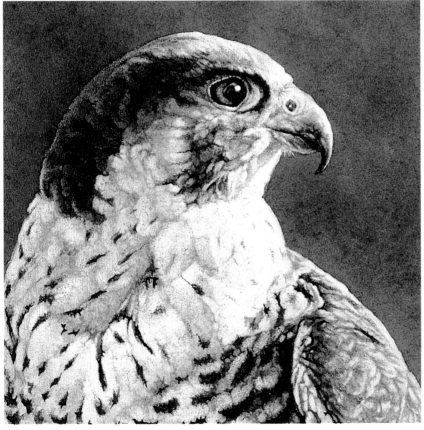

7 Colored-Pencil Step
Add Brights and Details

Use Cream pencil for the pale yellow cere on the falcon's bill. Shade it with Goldenrod pencil. Then use these same colors to shade the knob in the middle of the round nostril. Sharpen the tip and edges of the bill with Black and French Grey 10% pencils.

Shade the color in the eye with Burnt Ochre pencil. Draw more feathers on the head with French Grey 10%. Then soften their edges with Sepia pencil.

Draw markings on the feathers with Black pencil, and soften these with Sepia.

Warm up shadowy areas by glazing with Yellow Ochre pencil.

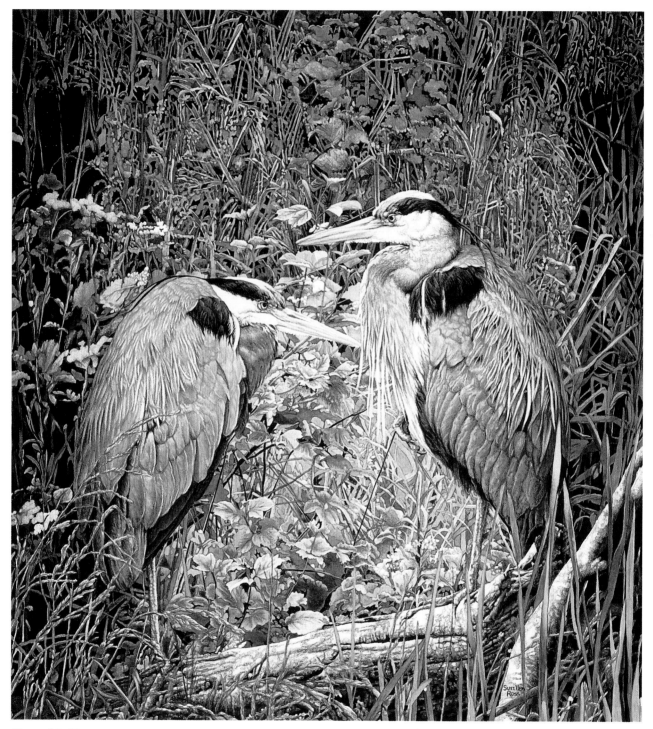

Courtship Dance

These great blue herons are involved in a courtship ritual. They face each other and bob up and down, first hunching over, then stretching to their full height, which is considerable.

In honor of their courtship, I designed a heart-shaped bower around them.

Use White pencil and Warm Grey Liquid Acrylic Color on the heron faces, chests and pale plumage. Then glaze with Burnt Umber watercolor, creating a pearly, peachy gray color. Paint the blue feathers in Payne's Grey watercolor, highlighted with White pencil and warmed with Raw Umber, Burnt Ochre, and Yellow Ochre pencils.

BRIDAL BOWER
18″ × 16″ (46cm × 41cm)

GREAT BLUE HERON

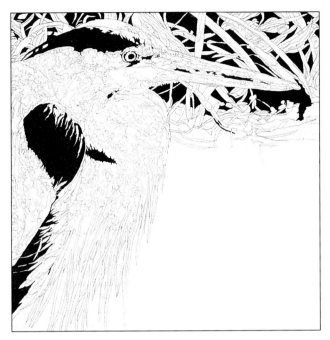

COLORS

WATERCOLOR
Burnt Sienna
Burnt Umber
Charcoal Grey
French Ultramarine
Neutral Tint
Payne's Grey
Permanent Sap Green
Quinacridone Gold
Raw Umber
Sepia
Warm Grey Liquid
 Acrylic Color

COLORED PENCIL
Burnt Ochre
Cream
French Grey 10%
Indigo
Light Umber
Sepia
Slate Grey
White

1 *Drawing/Inking Step*
Complete Drawing, Lay Ink

Once you've completed your graphite drawing, it is easy to see where to put ink; the great blue heron is divided into very pale and very black areas. However, even in the obviously black feathers of the heron, leave some highlights free of ink.

Ink forms the shadows between the reeds in the background slough.

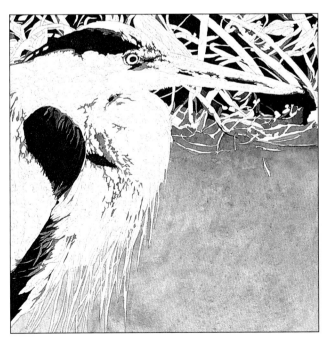

2 *Watercolor Step*
Paint Background and Darks

Mix French Ultramarine and Burnt Sienna as the water's color. Paint a wash of this color up to the reeds, carefully going around the chest feathers. While your paint is still wet, add extra French Ultramarine at the top. Add even more blue to your brush as you move up into the reeds.

Painting around all those feathers and reeds is tricky. To make your life simpler, use friskit or White pencil to protect the edges of the bird and the reeds, and then you can paint directly over them.

Let the water dry, and then select the darkest areas (after the ink) on the bird and in the reeds and paint these with Charcoal Grey watercolor.

Find the next-lighter areas in the reeds, and paint them with Sepia watercolor.

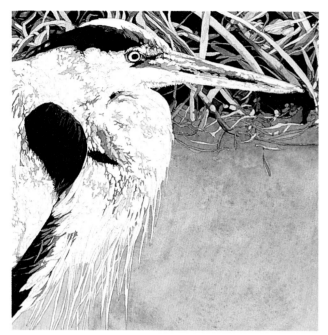

3 Watercolor Step
Build a Grisaille

Going from dark to light, paint in the reeds with Sepia, Burnt Umber and Permanent Sap Green. Shade all the lighter reeds with Warm Grey Liquid Acrylic Color. (You will add color to these later.)

Paint the shadow areas on the face and the body of the heron with Warm Grey acrylic.

Add Neutral Tint to the beak and head.

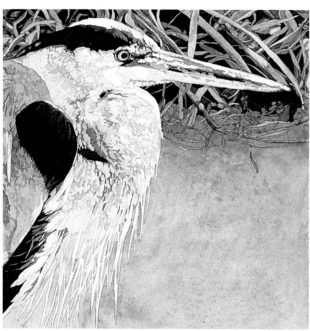

4 Watercolor Step
Continue the Grisaille

Use White pencil to highlight areas on the back, the face, bill, neck and chest feathers. Paint pale Warm Grey Liquid Acrylic Color over the lower bill and the neck and chest, working around and between the chest feathers. Then fill in midtones between these feathers with slightly darker Warm Grey acrylic.

Use Quinacridone Gold for the eye (leave white highlights on the left side) and for some reeds. Other reeds should get Raw Umber watercolor.

Do a pale wash of Payne's Grey over the whole back.

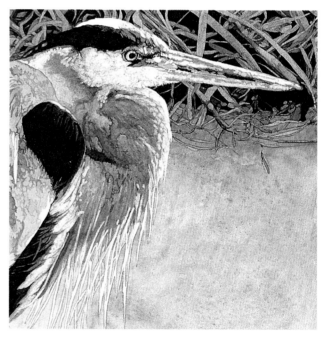

5 Watercolor Step
Finish the Grisaille

Select your next-lighter areas on the head, beak and chest. Protect them from further color with White pencil, and then wash over these areas with pale Warm Grey acrylic. Repeat this process for the next-lighter areas, and do another pale gray wash.

Apply a final touch-up with White pencil, making sure you protect everything that should be pale. Then apply a pale wash of Burnt Umber over the beak, the upper head, along the front edge of the chest and over all the white feathers.

Finally, mix a dark shadow color with French Ultramarine and Burnt Sienna. Paint a dark shadow of this color on the chest and neck. Then dilute this mixture, and glaze over the background. This will make the reeds recede further into the distance.

6 Colored-Pencil Step
Add Lights

Carefully erase all traces of graphite and White pencil. Notice how much cleaner your bird looks!

Using a White pencil, blend the very lightest areas into the slightly darker areas. Highlight the palest feathers.

Use French Grey 10% pencil to blend the darker areas on the head, neck and chest, avoiding the white feathers.

In the background, soften the ink edges with Sepia pencil. Connect the reeds, and soften all reed edges with Sepia, Burnt Ochre and Light Umber pencils.

Soften the water's edge with Indigo pencil. Submerge some of the reeds by lightly covering them with Indigo. Polish the blue water's edge with your finger to blend all the colors.

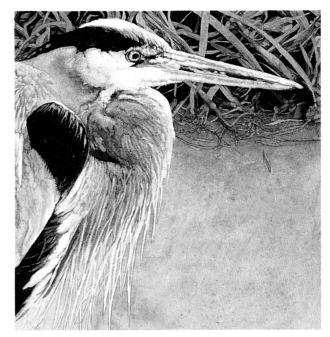

7 Colored-Pencil Step
Final Touches

On the top of the head, soften the black ink edge with Slate Grey pencil.

Sharpen the blue on the bill with Slate Grey. Then soften the ink edges on the bill (and everywhere else on the bird) with Sepia pencil.

Using Sepia, soften the darkest watercolor edges on the neck and shoulders, and add more definition between feathers in the dark areas.

In the lighter areas, shade and soften the harsh edges with Light Umber pencil.

Highlight the epaulet (black patch on the shoulder) with White pencil blended into the ink with Slate Grey.

Using Cream pencil, glaze the warm gray areas (including the bill) and burnish all the light colors.

Keep the white areas bright and clean.

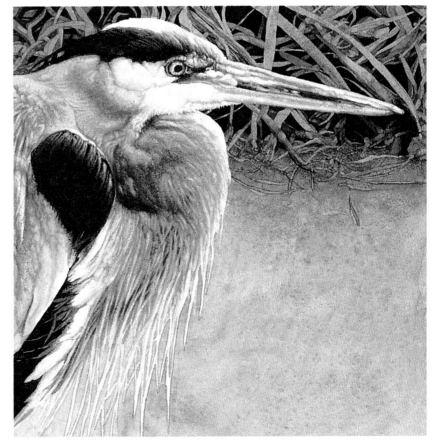

INDEX